MAGIC MOMENTS IN BC SPORTS

MAGIC MOMENTS

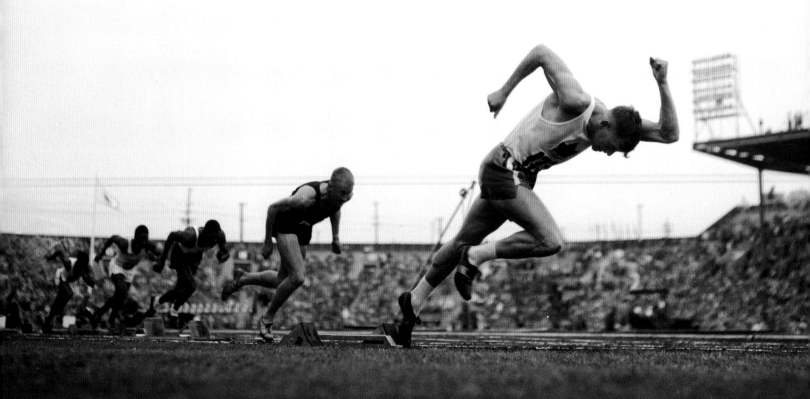

KATE BIRD

IN BC SPORTS

A CENTURY IN PHOTOS

GREYSTONE BOOKS

Vancouver/Berkeley

Acknowledgements

My heartfelt thanks to everyone who helped make this book possible: Harold Munro, editor-in-chief of the *Vancouver Sun* and the *Province*, Pacific Newspaper Group (PNG) librarian Carolyn Soltau, City of Vancouver archivist Heather Gordon and the rest of the CVA staff, BC Sports Hall of Fame curator and facility director Jason Beck, retired *Province* photographer John Denniston, PNG photographer Jason Payne, editor Derek Fairbridge, proofreader Jennifer Stewart, and Rob Sanders and all the wonderful folks at Greystone Books, especially Jennifer Croll, Nayeli Jimenez, Peter Cocking, Megan Jones, Josh Oliveira, and Jen Gauthier.

And to my husband, Bill, and my son, Darius, for the countless hours we've spent playing, watching, and discussing sports.

Front cover: BC Lions quarterback Doug Flutie, pictured in 1991, played with nine CFL and NFL teams, including the BC Lions, 1990–91. Flutie won three Grey Cups and was Grey Cup MVP with Calgary (1992) and Toronto (1996, 1997). **Jeff Vinnick/** *Vancouver Sun*

Back cover: Top row, from left: **Gerry Kahrmann/PNG, Gerry Kahrmann/PNG, Stuart Davis/PNG, Gerry Kahrmann/PNG;** middle row, from left: **Gerry Kahrmann/PNG, Stuart Davis/ PNG, Gerry Kahrmann/PNG, Les Bazso/PNG;** bottom row, from left: **Gerry Kahrmann/PNG, Ward Perrin/PNG, Gerry Kahrmann/PNG, Peter J. Thompson/Postmedia**

Frontispiece: New Westminster's Harry Nelson (right) led the 220-yard semifinal at the 1954 British Empire Games. A few days later, Nelson, Don Stonehouse, Bruce Springbett, and Don McFarlane won gold in the 4x110-yard relay. **Harry Filion/** *Vancouver Sun*

Greystone Books Ltd.
greystonebooks.com

Cataloguing data available from Library and Archives Canada
ISBN 978-1-77164-451-8 (pbk.)
ISBN 978-1-77164-452-5 (epub)

Editing by Derek Fairbridge
Proofreading by Jennifer Stewart
Cover design by Peter Cocking
Interior design by Nayeli Jimenez

Vancouver Sun and *Province* photos courtesy of Pacific Newspaper Group. Photos from other collections are credited in captions.

Printed and bound in Singapore on ancient-forest-friendly paper by 1010 Printing Group Limited

Greystone Books gratefully acknowledges the Musqueam, Squamish, and Tsleil-Waututh peoples on whose land our office is located.

Greystone Books thanks the Canada Council for the Arts, the British Columbia Arts Council, the Province of British Columbia through the Book Publishing Tax Credit, and the Government of Canada for supporting our publishing activities.

CONTENTS

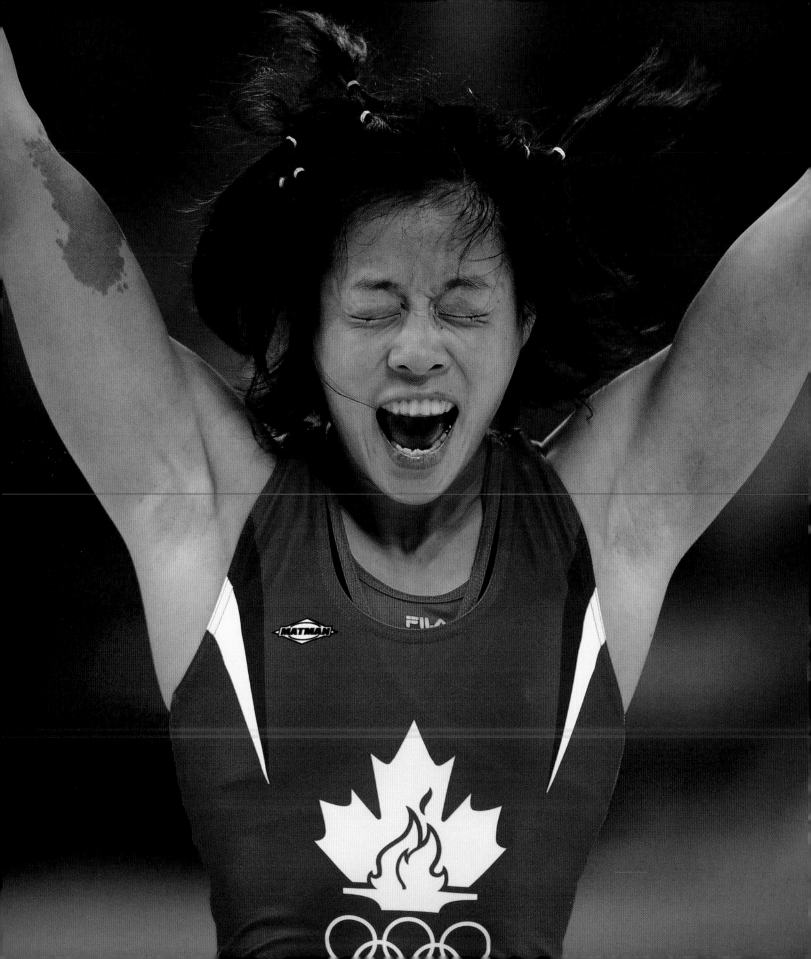

CHAMPIONS OF OUR OWN

KATE BIRD

THERE IS SOMETHING uniquely compelling about a photograph of a sporting moment. The complex beauty of an unscripted instant—the physique and facial expression of the athlete as they navigate the fine line between the triumph of victory and the heartbreak of loss—is inherently dramatic and touchingly human. A photograph can evoke the charged atmosphere and chaotic environment, encapsulate the mood and magic, in a way that a televised event cannot, capturing a single image that lingers indelibly in our memory.

Over the past century, photojournalists from the *Vancouver Sun* and the *Province*, and other local photographers, have had a front-row seat to the action. Using technical skill, experience, and artistry, they have endeavoured to document a fleeting moment that can tell a story. The constant advancement of photographic technology—from the 4x5-inch Speed Graphic camera, to 2¼-inch and 35mm cameras, to flashbulbs, faster shutters and film, telephoto lenses and motor drives, to modern digital cameras—has enabled photographers to better capture that elusive perfect shot. Regardless of the camera equipment available over the past hundred years, it is the photojournalist's well-trained eye and unique point of view that have produced sports photographs that have the power to astonish.

In multicultural British Columbia, sports provided a way to honour and preserve cultural heritage and to build and support local communities. War-canoe races provided a showcase for the sophisticated canoe designs and exceptional paddling skills of Indigenous people on British Columbia's coast, and were both demonstrations and celebrations of cultural identity. Immigrants introduced a variety of sports to the province: Scottish settlers organized the Caledonian Games, South Asians competed in kushti wrestling, and the Japanese established sumo, kendo, and judo clubs. Lacrosse migrated from eastern Canada, baseball came north from the U.S., the English brought cricket, golf, rugby, and soccer, Europeans introduced alpine sports, and the Chinese launched dragon boating.

As the amount of leisure time increased through the early 1900s, community members, local businesses, and schools organized recreational sports teams, leagues, and a wide range of sporting events. Photographs of the period show how multi-ethnic the teams and fans often were. One uniquely successful community team was the Vancouver Asahi baseball club. From 1914 until 1942—the year that Japanese Canadians in British Columbia were ordered to internment camps during the Second World War—the Asahi's skilful and strategic playing style and domination of the Pacific Northwest League made the Japanese community proud and won over a legion of non-Japanese fans.

Local athletes who sought to compete on a bigger stage faced the disadvantage inherent in living and training on Canada's West Coast. Not only did they lack access to the more organized sports clubs, training facilities, and coaches available in cities like Toronto

Facing: Hazelton's Carol Huynh won gold in 48-kilogram wrestling at the 2008 Olympics (pictured), bronze at the 2012 Olympics, gold at the 2007 and 2011 Pan-Am Games, gold at the 2010 Commonwealth Games, and medalled at four World Championships. **Larry Wong/Postmedia**

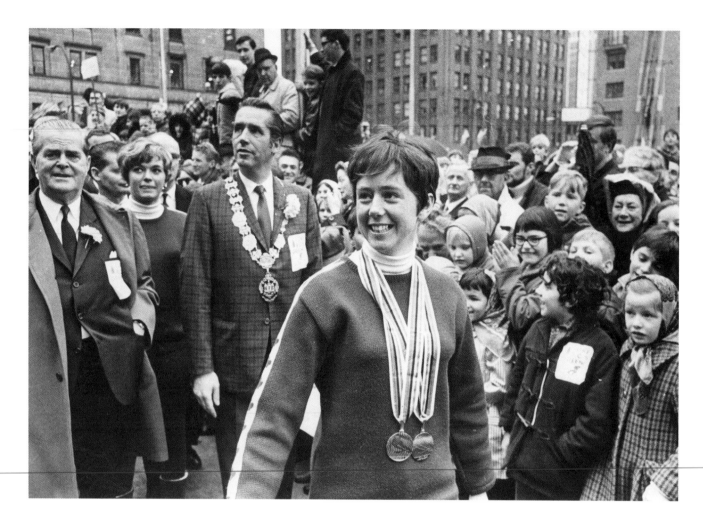

and Montreal, but a lack of local funding and the expense of the long trip often prevented them from attending national competitions and Olympic tryouts in eastern Canada.

Canada's first Olympic flag-bearer and British Columbia's first-ever individual Olympic medal winner was Vancouver policeman Duncan Gillis, who won a silver medal in 16-pound hammer throw at the 1912 Olympics in Stockholm. Vancouver's fifteen-year-old Lillian Palmer qualified but was declared ineligible for the 1928 Olympics in Amsterdam, despite there being no official age limit, a decision that denied her the honour of competing on Canada's first women's Olympic team. Four years later, at the 1932 Olympics in Los Angeles, Palmer and Nanaimo's Mary Frizzell

became British Columbia's first female Olympians and Olympic medallists when they won silver as members of the women's 4x100-metre sprint relay team.

With limited media exposure, early British Columbia athletes remained virtually unknown outside the province. As a result, they sometimes burst onto the Canadian and international sports scene in a surprising manner. "Percy Williams Puts City on Map," the *Vancouver Daily Province* headline declared when Williams won two gold medals in the 100-metre and 200-metre sprints at the 1928 Olympics, a performance so unexpected that it made news worldwide. That a shy and scrawny twenty-year-old "native son of our own" from East Vancouver could become the fastest man in the world was an astonishing feat. When

Above: Vancouver fans celebrate Olympic skier Nancy Greene in 1968. From left, BC Premier W.A.C. Bennett, skier Judi Leinweber, and Vancouver mayor Tom Campbell. **Ross Kenward/*Province***

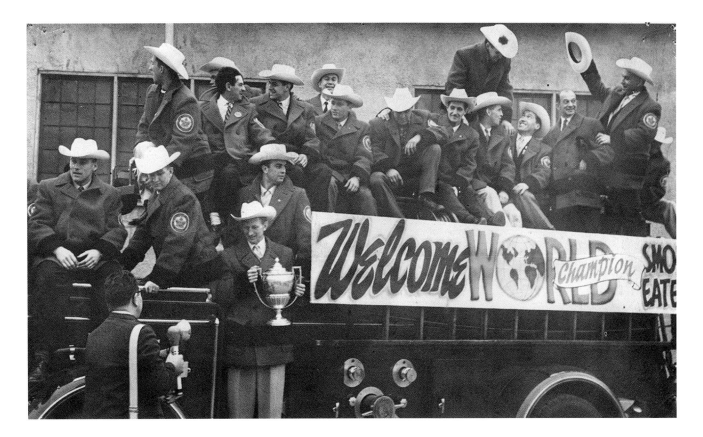

he arrived home on September 14, 1928, a band played "See, the Conquering Hero Comes" as thousands of adoring fans lined Granville and Georgia streets, from the CPR station to Stanley Park, to cheer "their Percy" as he rode in an open car with British Columbia premier S.F. Tolmie.

International success by Canadian athletes was once a relatively rare event, and our British Columbia champions made us particularly proud.

The Trail Smoke Eaters were chosen to represent Canada at the 1961 World Ice Hockey Championships in Switzerland after the Chatham Maroons, who had won the Allan Cup, awarded to the nation's top senior amateur men's hockey team, declined to participate. The citizens and businesses of Trail and its surrounding communities raised the $23,000 needed for the team to make the trip, and the Smoke Eaters went on to win the championship, repeating a feat accomplished by a 1939 Smoke Eaters team. On March 19, 1961, five

hundred cars followed the team for the thirty-kilometre drive from Castlegar Airport to Trail, where a crowd of 12,000 celebrated in the streets.

When Rossland skier Nancy Greene arrived in Nelson on March 4, 1968, having recently won a gold medal in the giant slalom and a silver medal in the slalom at the 1968 Olympics in Grenoble, the citizens blew their car horns, whistled, and yelled along a two-mile-long cavalcade through town. "She has become a starlet, a kind of female Beatle," the *Vancouver Sun* reported. North Vancouver figure skater Karen Magnussen was welcomed home after winning the 1973 World Championships with, among other events, a 21st birthday party on April 4 at the Pacific Coliseum. Magnussen and other top skaters performed for the audience of 16,000, and afterwards she was showered with gifts, including a colour television, a mink coat, tickets to Hawaii, a diamond ring, and a white Ford Mustang.

Above: A huge homecoming party awaited the Trail Smoke Eaters on their return from Europe after winning the World Ice Hockey Championships in 1961. **Trail Historical Society**

The international success of British Columbia athletes helped to put us on the map and inspired home province pride. Because when athletes succeed, it's not just a win for them, it's also a win for their coaches, trainers, and training partners; the team or program they belong to; their parents, family, and friends; and their fans and hometown community. Their achievement becomes our achievement, and we, as a province, embrace them as champions of our own. Perhaps the passion, perseverance, and commitment of these winning athletes symbolize our own secret dreams and ambitions and represent the best of who we are and who we want to be.

On September 9, 1979, 100,000 fans, the biggest crowd ever accorded a Vancouver team in any sport, mobbed the Robson Street parade organized to celebrate the Vancouver Whitecaps winning the North American Soccer League Soccer Bowl. Hometown hero Bob Lenarduzzi told the crowd at Robson Square, "I'd just like to say, having been born and raised in Vancouver, that this is the proudest moment of my life, seeing all you people here."

While sports are a casual entertainment for some, and some fans are happy to hop on the bandwagon

from time to time, for others, sports represent a full-blown obsession. That passion can sometimes erupt into hooliganism and violence. There were riots in downtown Vancouver in 1994 and 2011 after the Vancouver Canucks lost game seven of the Stanley Cup Final in both those seasons, and Grey Cup riots in 1955, 1958, 1963, and 1966. Hockey analyst Elliotte Friedman recently commented that local fans had an "us versus them" mentality not found in any other sports market. A statue outside Rogers Arena embodies our fatalistic attitude toward getting a fair shake—Canucks coach Roger Neilson holding a white towel aloft on a hockey stick, surrendering in protest over a bad call in the 1982 Stanley Cup Playoffs.

But while sports can sometimes foment discord, sports can also be a unifying force, sweeping people up into a shared communal experience, their differences set aside to cheer together as one. To be part of the crowd at a sporting event can be a transporting experience—to feel the synergy, the ebb and flow of the crowd's energy as they collectively will the individual or team on to victory, how the air can be sucked out of the atmosphere by a setback, how it rises again when the tide turns. It is these moments—the winning, the losing, and everything before, after, and in between—that draw us as fans to the unscripted drama and excitement of sports.

In 2010, the Winter Olympic Games in Vancouver inspired a unique spirit of community celebration and a strong outpouring of civic pride. For seventeen days and nights, people filled the city's streets to enjoy community events, music concerts, medal ceremonies, and fireworks displays. As *Province* reporter Ed Willes wrote, "Sometime about Day 3 of the circus, the people took over the Olympics and made them memorable and magical. In the process, they created an atmosphere which was joyous and an energy that took your breath away."

The photographs in this book are a highly selective and eclectic mix of familiar and unknown images

Above: Vancouver's Lui Passaglia, the BC Lions place-kicker and punter, 1976–2000, won three Grey Cups with the team, in 1985, 1994 (pictured), and 2000. **Arlen Redekop/*Province***

vividly evoke moments of beauty and perfection and events that have inspired and moved us. The photograph on page 26 of the maple leaf on Percy Williams's jersey as he crosses the finish line to win gold at the 1928 Olympics inspired George F. Stanley's design of the Canadian flag.

Each generation of sports fan will recall their favourite British Columbia athletes, the champions of their era, or their own personal sports hero or heroine. You may have been in Trail for the Smoke Eaters' triumphant homecoming, or you may have been in the crowd at BC Place when Vancouver's Lui Passaglia kicked the field goal that won the BC Lions the 1994 Grey Cup. You may have watched in amazement as rower Silken Laumann of Victoria, only ten weeks after suffering a devastating injury, came back to win a bronze medal at the 1992 Olympics in Barcelona, or cheered when North Vancouver's Maëlle Ricker became the first Canadian woman to win a gold medal on home soil at the 2010 Olympics. They were, and are, winners—the best of us, our pride and joy. Our very own homegrown champions.

My hope is that the photographs in this book will trigger your own memories or provide fresh discoveries and insights. For these images not only chronicle some of our province's athletes, sports teams, and sporting events, they document magic moments in the social history of our province. They tell a story, a very human story, our story, of how sports have helped shape and define our culture, identity, and sense of place, strengthened our ties to community, touched, and inspired us.

showcasing the breadth of sports in our province. They include amateur and recreational athletes, Little Leaguers and Olympians, Paralympians, professional athletes and world champions. There are award-winning images, photographs of community and global events, logging sports and bathtub races, portraits, and action shots of famous and little-known athletes training, practicing, competing, falling short, and celebrating. And, of course, there are photos of sports fans, caught up in the thrilling drama of the action, and revelling in, or lamenting, the outcome.

Czech novelist Milan Kundera wrote that "memory doesn't make films. It makes photographs." Photographs are powerful triggers for memory and imagination, and sports photographs in particular can

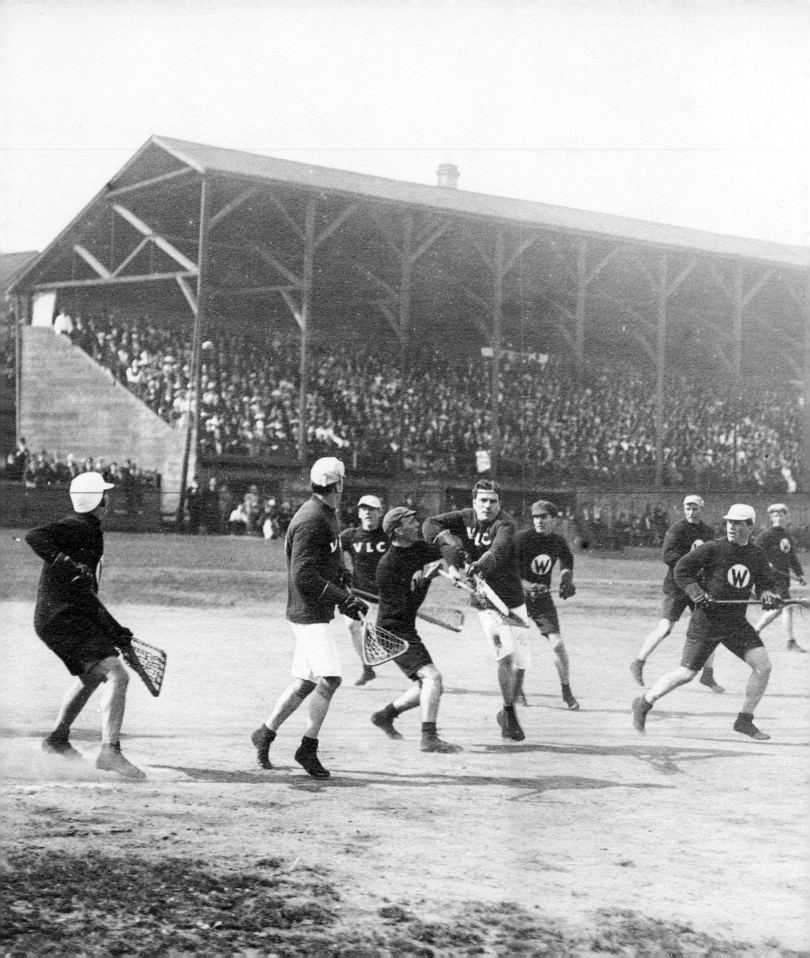

TO 1939

THE FIRST FORMAL canoe competition in the Colony of British Columbia took place in Nanaimo on Queen Victoria's birthday in 1862. European paddlers competed for a thirty-dollar prize, and in a separate event, the Comox team beat ten other Indigenous teams for a thirteen-dollar prize. In 1865, the New Westminster *British Columbian* reported that more than 8,000 Indigenous people attended Queen Victoria's birthday party. In a series of canoe races on the Fraser River that lasted all afternoon, twenty canoes at a time, each manned by twenty-one paddlers, raced to the finish line. First place winnings ranged from twenty-four dollars to forty-four dollars, and all competitors received a plug of tobacco.

In the early 1900s, sports were a welcome diversion for multi-ethnic workers around the province. People participated in a range of individual sports and activities and on teams and clubs organized by local communities.

Sports venues and facilities sprang up all over the province. Recreation Park, Vancouver's first completely fenced sports ground, was constructed at Smithe and Homer streets in 1905, and became home to the Vancouver Beavers baseball team in 1908. In 1911, the Patrick family, who helped establish professional hockey in Canada, opened the 4,000-seat Patrick Arena in Victoria and the 10,500-seat Denman Arena in Vancouver. Bob Brown's Athletic Park opened in 1913 at Hemlock Street and 5th Avenue, and when floodlights were installed in 1931, it became the first sports venue in Canada to host night games. In 1916, Nels Nelsen constructed Canada's first permanent ski jump in Mount Revelstoke National Park.

During these years, attending a game on Saturday became a favourite family activity, and improved transportation enabled spectators to attend a greater variety and number of sporting events. When the Lower Mainland's population was only 60,000, crowds of several thousand attended lacrosse games between rival Vancouver and New Westminster teams. British Columbia's love affair with sports was off and running.

Facing: The New Westminster Salmonbellies, pictured in a game against the Vancouver Lacrosse Club at Recreation Park circa 1910, won the Mann Cup twenty-four times between 1915 and 1991, first as a field lacrosse team, then box lacrosse. **W.J. Cairns/City of Vancouver Archives 371-2946**

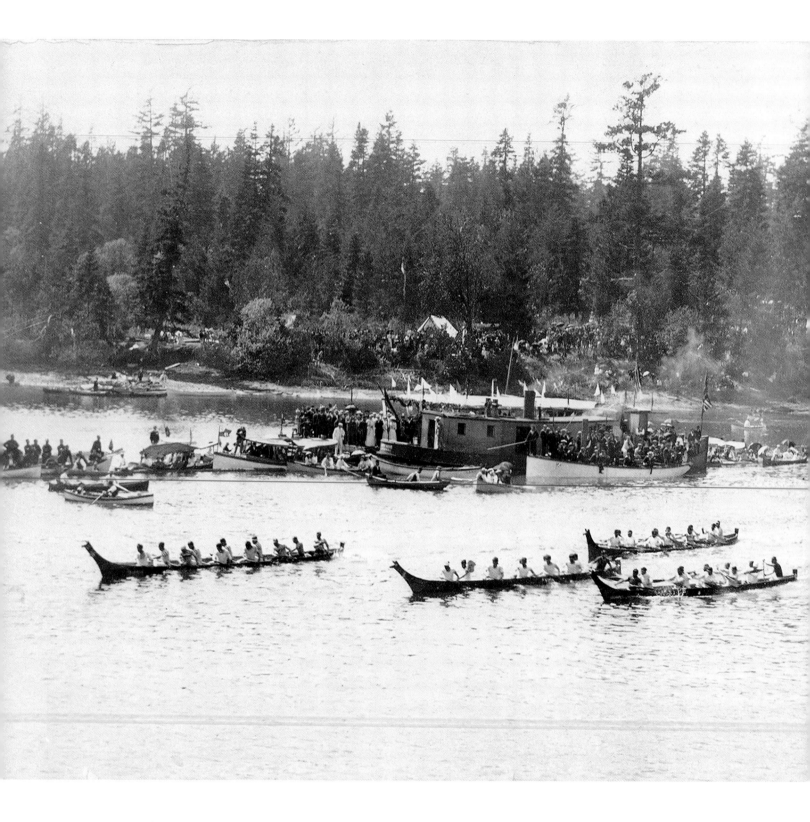

Above: At the annual Victoria Regatta, races between Indigenous communities were the most celebrated. Pictured is a May 22, 1899, war-canoe race. **Library & Archives Canada PA-112273**

Facing: Sikh men compete in a traditional South Asian style of wrestling called kushti, circa 1910. **Kohaly Collection, Special Collections and Rare Books, Simon Fraser University Library**

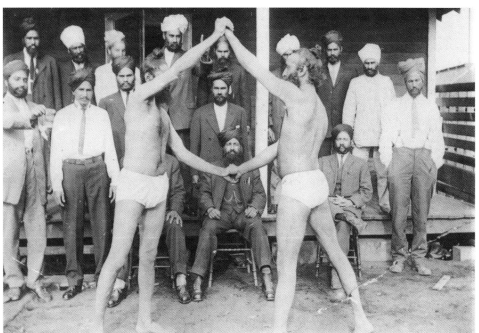

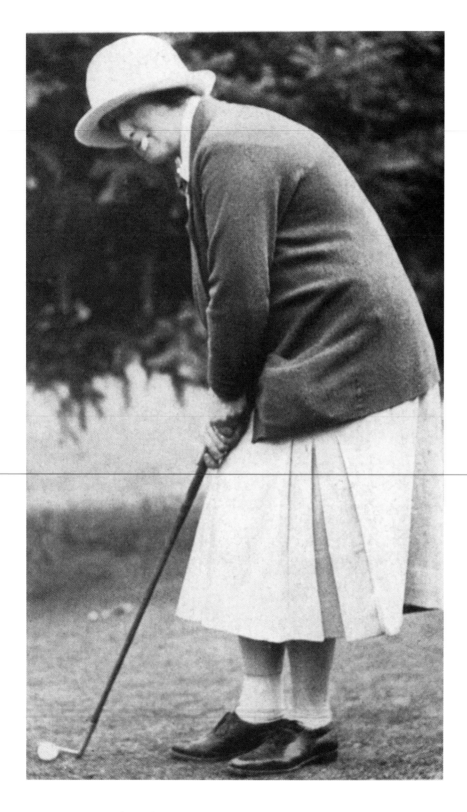

Above: Victoria's Violet Pooley Sweeny won nine BC championships and seven Pacific Northwest Golf Association championships between 1905 and 1930. **BC Golf House Society**

Facing top: A sumo wrestling club, wearing ceremonial kesho-mawashi, at the Vancouver Japanese Language School sports day in Steveston in 1911. **Vancouver Public Library 86023**

Facing bottom: Vancouver lightweight boxing champion Len Holliday (right) in a match in New Westminster, circa 1914. **Stuart Thomson, City of Vancouver Archives 99-1275.1**

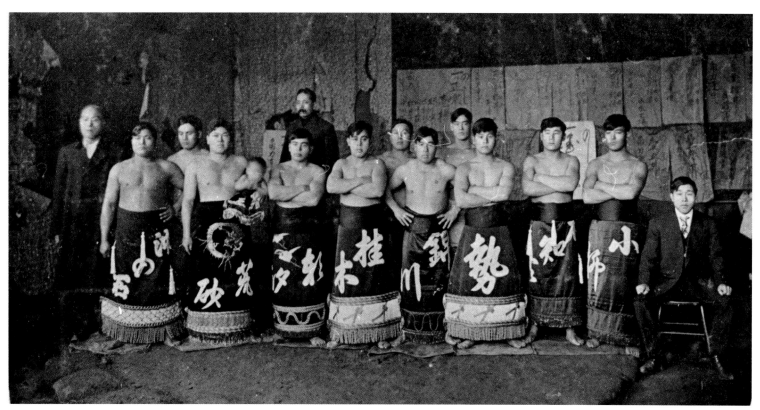

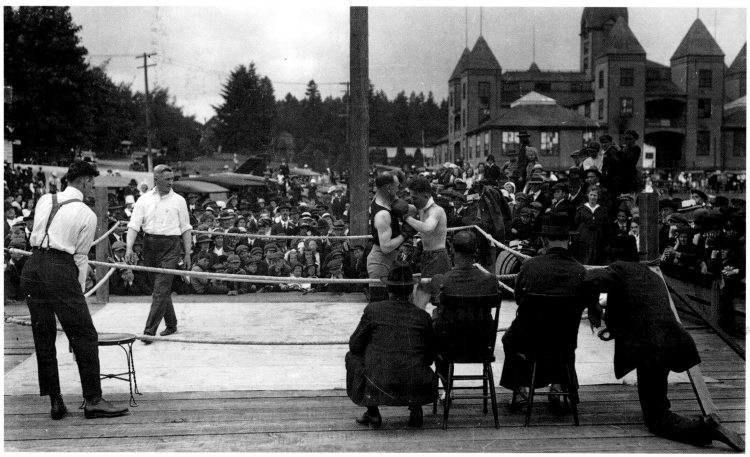

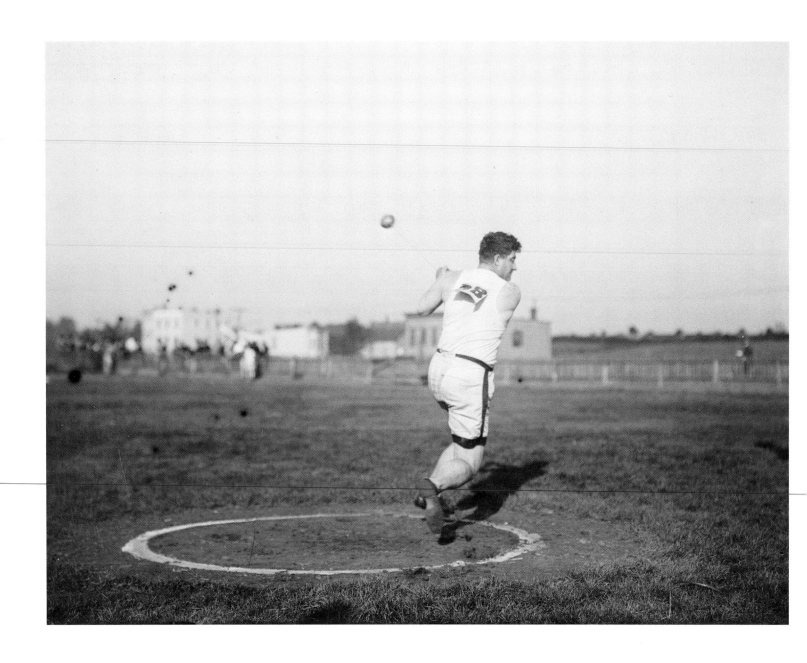

Above: Vancouver policeman Duncan Gillis, BC's first Olympic medallist, won a silver medal in the 16-pound hammer throw at the 1912 Games. **Bain News Service Collection/Library of Congress**

Facing: Revelstoke's Nels Nelsen established ski jumps at Revelstoke and Grouse Mountain, won numerous championships, and set hill and world records. **Revelstoke Museum & Archives P2098**

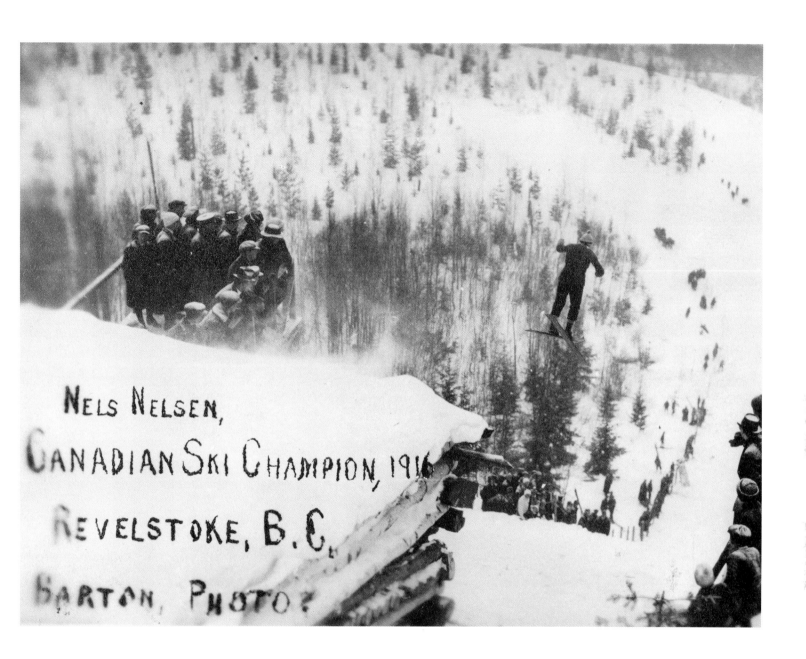

NELS NELSEN,
CANADIAN SKI CHAMPION, 1916
REVELSTOKE, B.C.
BARTON, PHOTO.

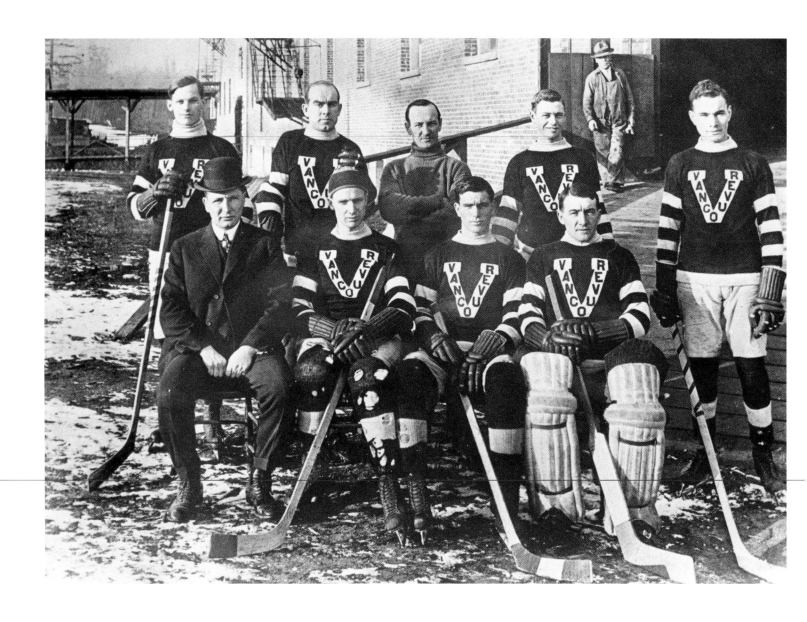

Above: Vancouver Millionaires 1915 Stanley Cup–winning team. From left, Johnny Matz, Frank Patrick, Fred "Cyclone" Taylor, Si Griffis, Mr. Miller (trainer), Lloyd Cook, Mickey McKay, Hugh Lehman, Frank Nighbor. **BC Sports Hall of Fame**

Facing top: Vancouver Amazons 1914 hockey team. From left, Connie Smith, Mrs. French, Elizabeth Hinds, Peter Muldoon (manager), Mrs. L.N. McKechnie, Nellie Haddon, Mrs. Percival, Miss Matheson. **City of Vancouver Archives 99-58**

Facing bottom: Victoria Cougars 1925 Stanley Cup–winning team: John Anderson, Wally Elmer, Frank Foyston, Gordon Fraser, Frank Frederickson, Hal Halderson, Harold Hart, Happy Holmes, Clem Loughlin, Harry Meeking, Lester Patrick, Jack Walker. **BC Sports Hall of Fame**

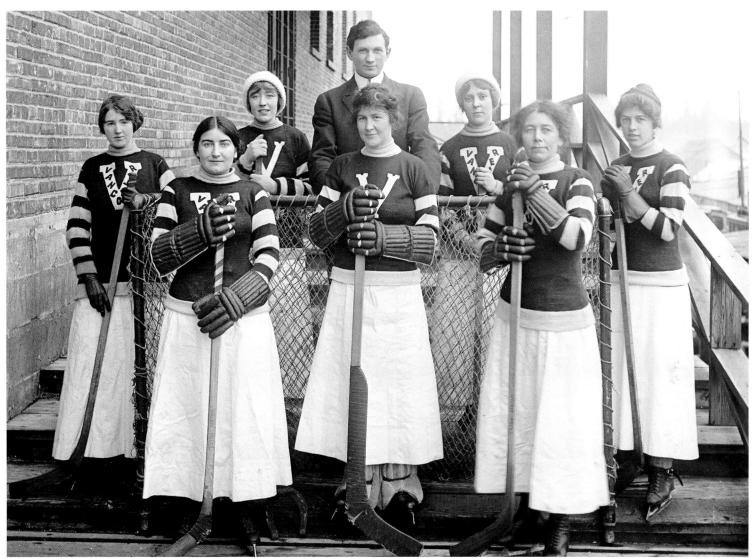

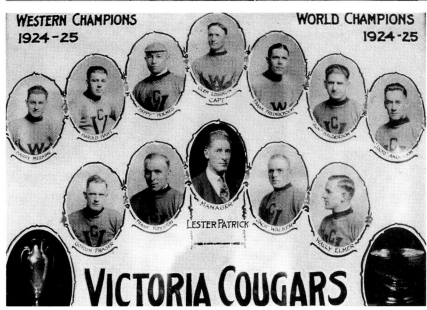

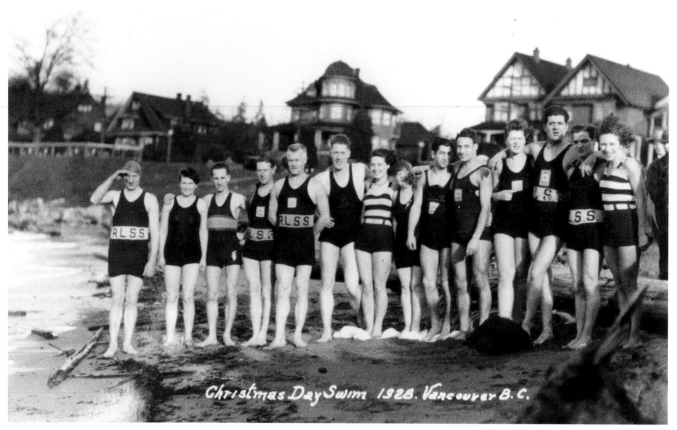

Christmas Day Swim 1928. Vancouver B.C.

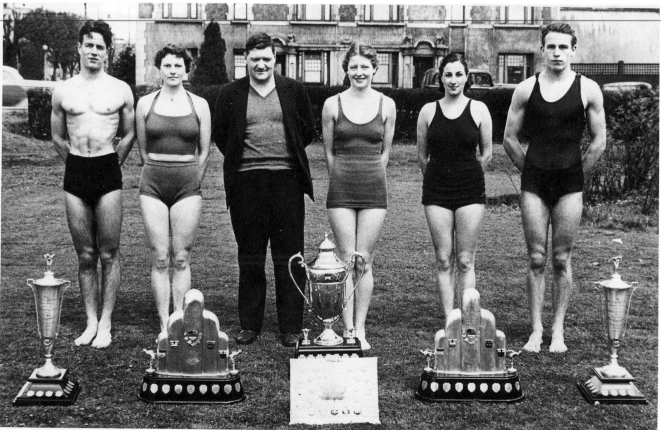

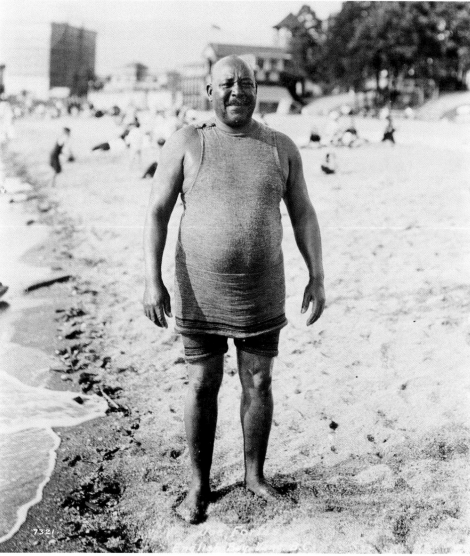

Facing top: The polar bear swim in English Bay, initiated on Christmas Day 1920 by Peter Pantages, pictured fifth from right in 1928, later moved to New Year's Day. **City of Vancouver Archives 99-1729**

Facing bottom: Percy Norman, head swimming and diving coach at the Vancouver Amateur Swim Club, 1931–55, coached Canada's 1936 Olympic and 1954 British Empire Games teams. *Province*

Above left: Diver Lynda Adams won two silvers at the 1938 British Empire Games, and was 1939 Canadian diving champion. *Vancouver Sun*

Above right: Joe Fortes, Vancouver's first lifeguard, taught generations of children to swim and saved more than twenty-nine lives. **Vancouver Public Library 21746**

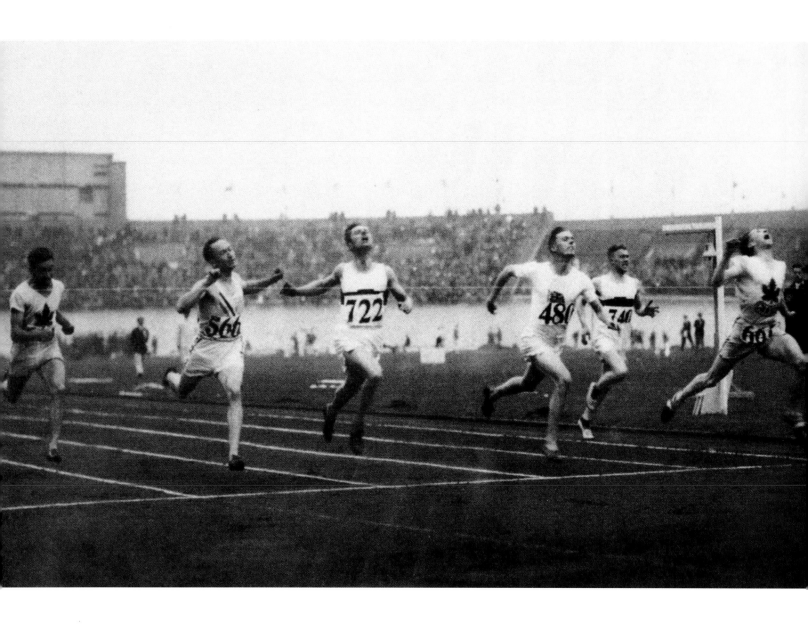

Above: Vancouver's Percy Williams (right) won gold medals in the 100-metre and 200-metre (pictured) races at the 1928 Olympics in Amsterdam and became a national hero. **BC Sports Hall of Fame**

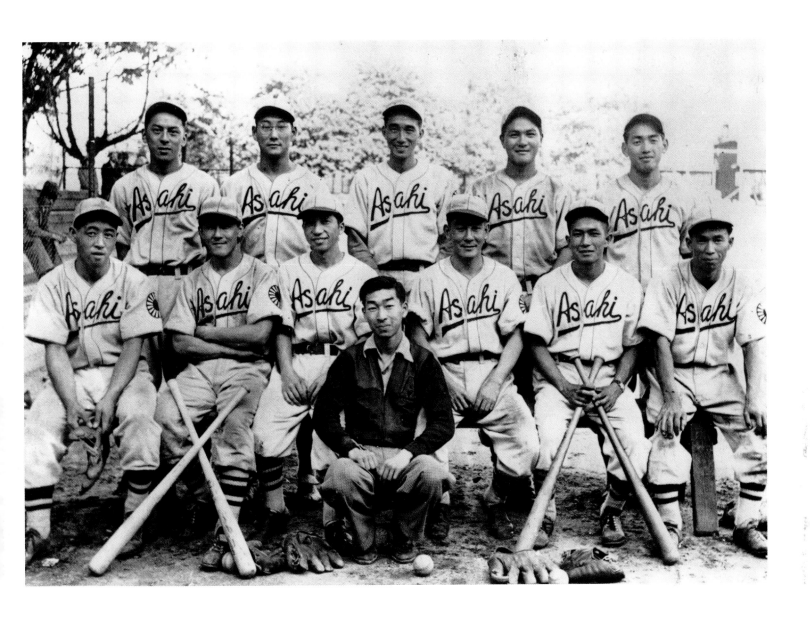

Above: The Vancouver Asahi baseball team was active 1914–42, before many players were interned during the Second World War. Pictured is the 1941 team. Back, from left, Yuki Uno, Eddie Nakamura, Naggie Nishihara, Koei Mitsui, Kaz Suga. Front, from left, Mike Maruno, Ken Kutsukake, George Shishido, Roy Tamamura, Tom Sawayama, Frank Shiraishi. Centre, Kiyoshi Suga. **BC Sports Hall of Fame**

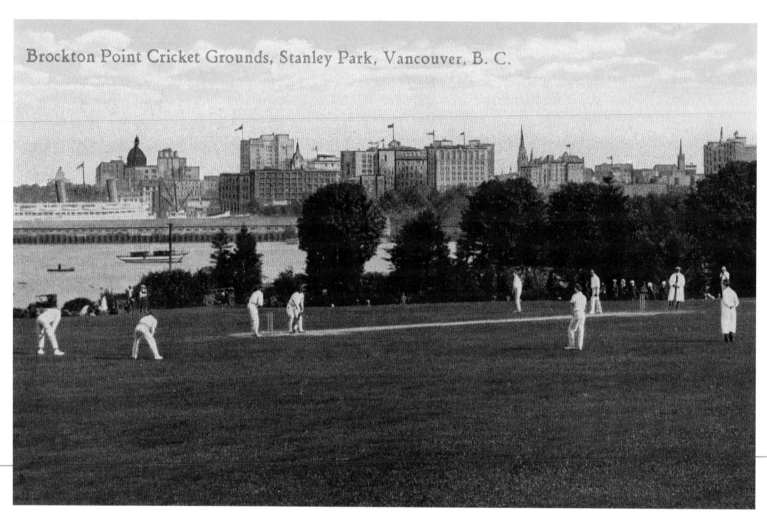

Brockton Point Cricket Grounds, Stanley Park, Vancouver, B. C.

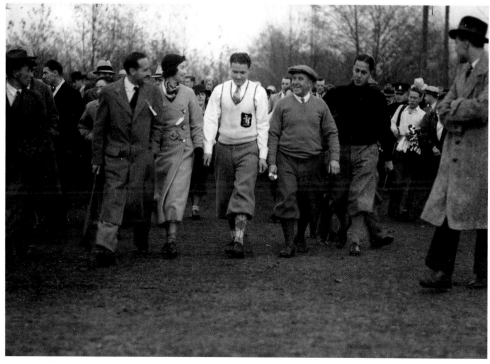

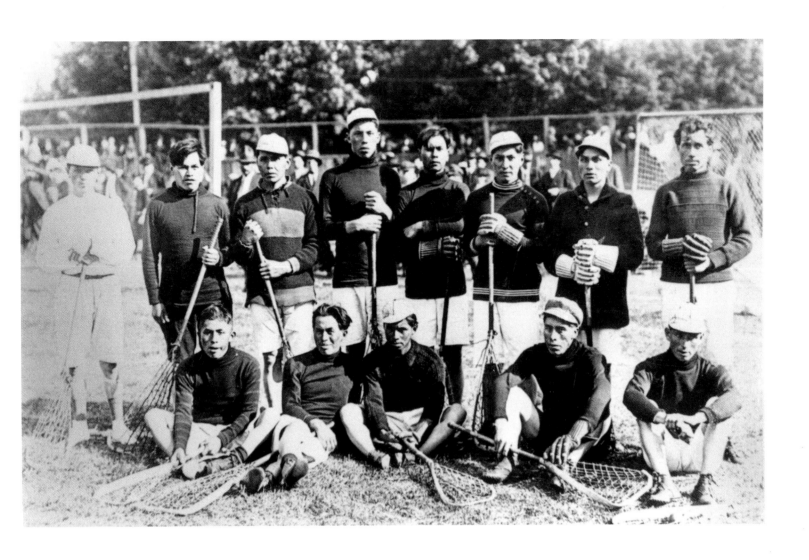

Facing top: The Brockton Point athletic fields at Stanley Park opened in 1891 to serve a variety of sports, including the Brockton Point Cricket Club. **Museum of Vancouver Collection H2008.23.270**

Facing bottom: Ken Black (white sweater), with father David in 1934, won the 1936 Vancouver Golden Jubilee tournament at Shaughnessy Golf Club, among many championships. *Vancouver Sun*

Above: Musqueam lacrosse team, 1930s. Back, from left, Abraham Point, Paddy Johnny, Gabriel Joe, Herman Guerin, Edward Sparrow, Sam Grant, Andrew Charles, Johnny Point. Front, from left, Alec Peters, Aloysius Peters, Joe Peters, Henry Louis, James Point. **City of Vancouver Archives AM1533-S2-4**

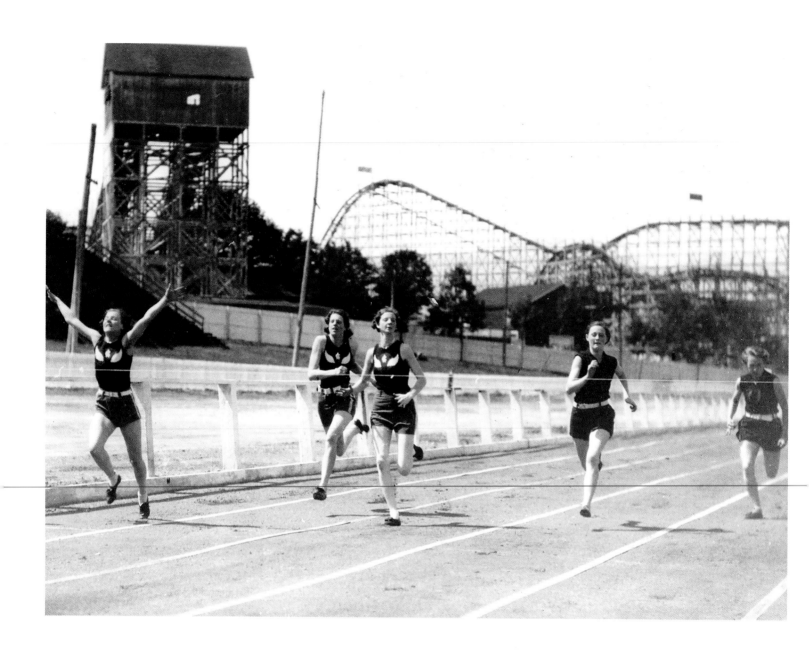

Above: BC's first female Olympians, Lillian Palmer (third from left) and Mary Frizzell (left), pictured at Hastings Park, won silver on the 4x100-metre relay team at the 1932 Olympics. **BC Sports Hall of Fame**

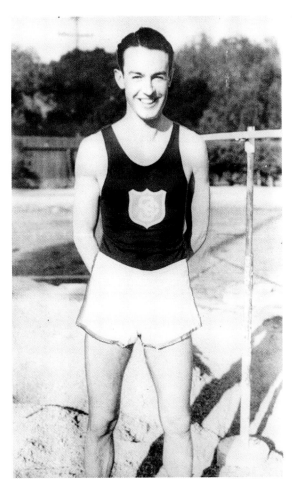

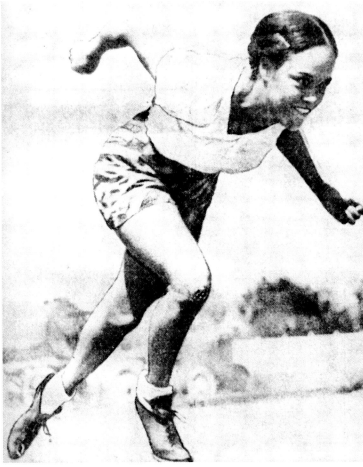

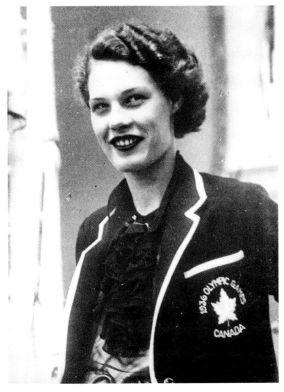

Above left: Vancouver's Duncan McNaughton won gold in high jump at the 1932 Olympics. **City of Vancouver Archives 371-1728**

Above right: Barbara Howard, the first black woman to represent Canada in international competition, won silver and bronze at the 1938 British Empire Games. **BC Sports Hall of Fame**

Left: Vancouver's Margaret Bell won bronze in high jump at the 1934 British Empire Games, and competed at the 1936 Olympics. **City of Vancouver Archives 371-412**

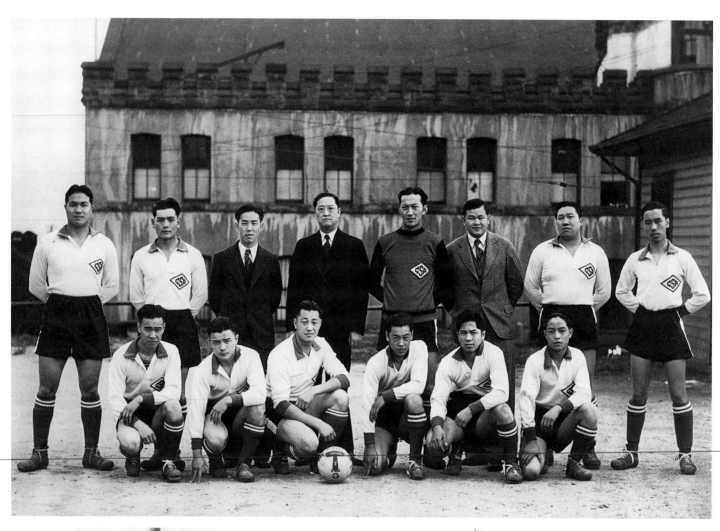

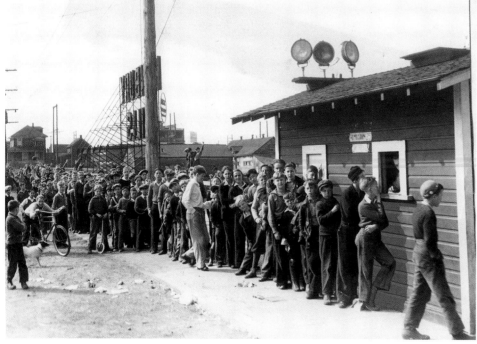

To my friend Bruce
Sincerely.
Jimmy McLarnin

Facing top: The Chinese Students soccer team (1920–42) won the 1933 Mainland Cup: Gordon Chang, Gam Jung, George Lam (secretary), William Lore, Charles Louie, Jackson Louie, Lem On, Buck Sing Chung, Jack Soon, Frank Wong, Shupon Wong, Art Yip, Dock Yip, Gibb Yip, Horne Yip, Quene Yip. **BC Sports Hall of Fame**

Facing bottom: Vancouver's Athletic Park, built by Bob Brown in 1913 for the Vancouver Beavers baseball team, provided cheap season tickets for kids in 1934. *Vancouver Sun*

Right: Vancouver boxer Jimmy McLarnin won the World Welterweight title in 1933 and 1934. **City of Vancouver Archives 1088-17**

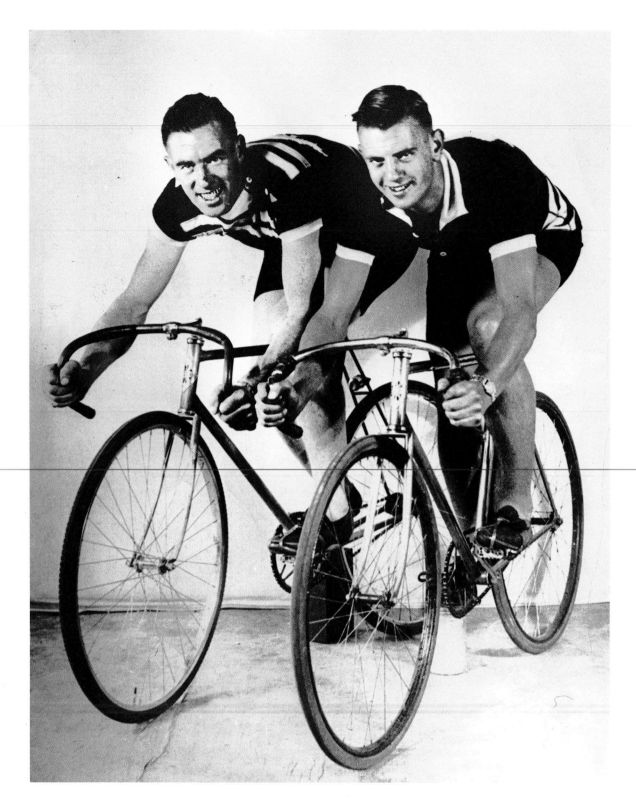

Above: Victoria's Bill "Torchy" Peden (left) and Doug Peden in 1937. Torchy won twenty-six six-day bicycle races, and brother Doug excelled in eleven sports. **Postmedia**

Facing: Winners Charlie Walker and Margaret Gale were among two hundred competitors in the tenth annual *Vancouver Sun* walking marathon in 1938. ***Vancouver Sun***

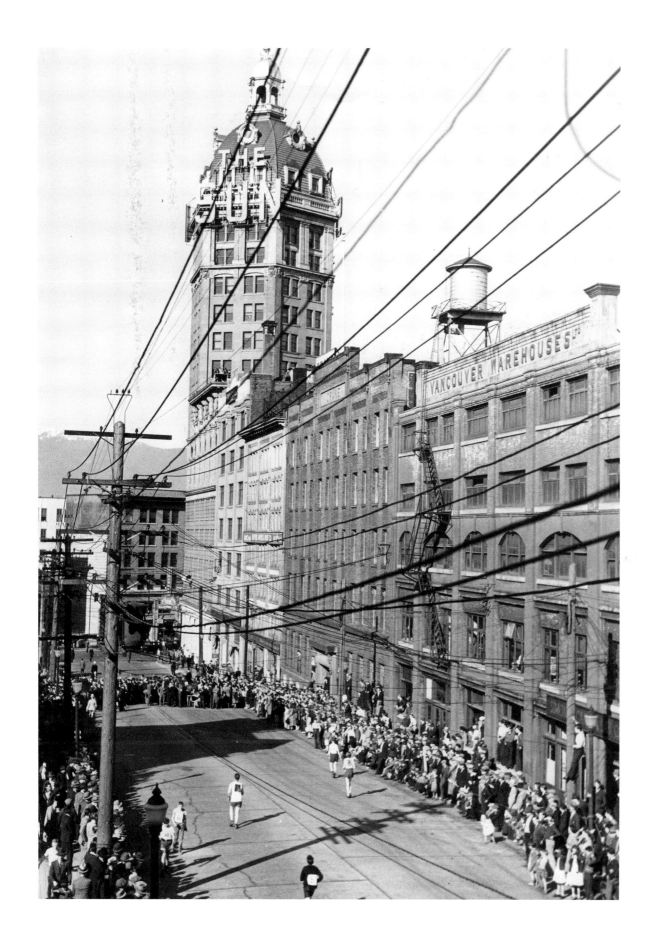

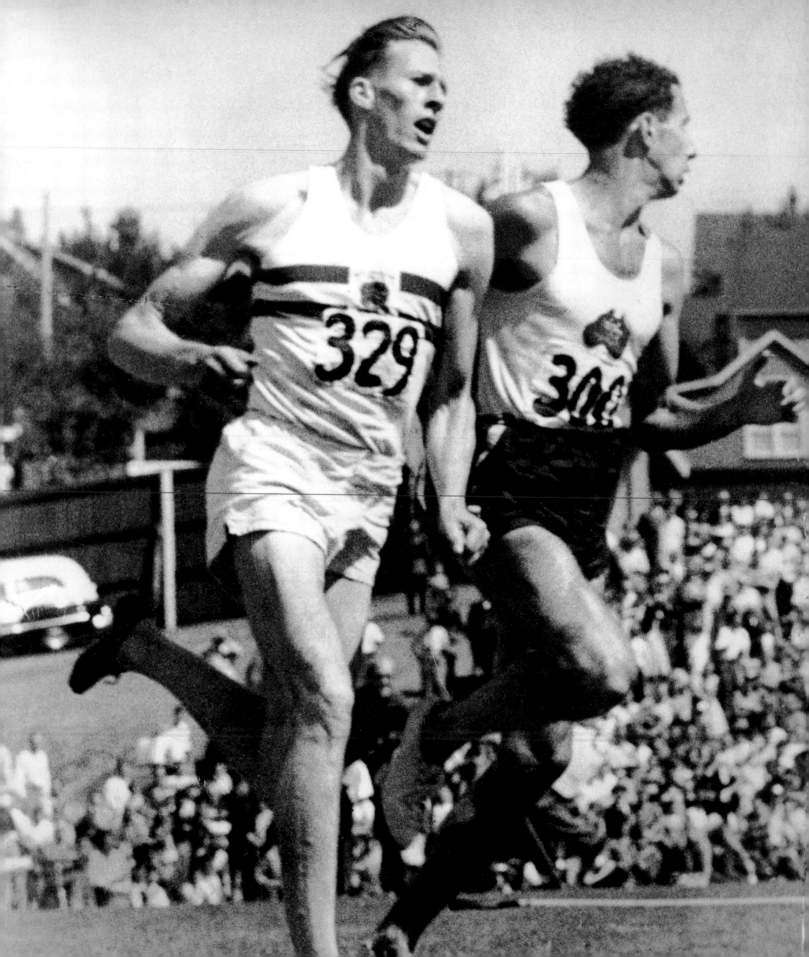

1940s & 1950s

WHEN VANCOUVER'S BID to host the 1954 British Empire and Commonwealth Games was successful, it set in motion a period of sports development whose impact reverberated for decades. The Games not only brought excitement and civic pride to British Columbians, they forged new sports alliances, spurred athlete advancement, and left a legacy of new sports venues that made future athletic endeavours possible. Empire Pool at the University of British Columbia was in service for over sixty years, and Empire Stadium, the largest stadium in Canada at the time, with a capacity to hold more than 32,000 spectators, became the home for the province's new Canadian Football League franchise, the BC Lions, and it later was home to the Vancouver Whitecaps.

The Games were held July 30 to August 7, 1954. The *Vancouver Sun* reported that the opening ceremonies were an overpowering spectacle, the greatest athletic event the province had ever seen. Canada placed third out of twenty-four participating nations. World-champion weightlifter Doug Hepburn was the only Vancouver athlete to win an individual gold medal, the UBC/Vancouver Rowing Club men's eight team won a surprise gold medal, swimmer Helen Stewart won a silver in the 4x100-metre relay, and Alice Whitty won bronze in high jump.

The crowning glory of the Games took place on the final day of competition when England's Roger Bannister and Australia's John Landy, who had each run the mile distance under four minutes in previous races, raced against each other for the first time. Before a capacity crowd at Empire Stadium, and with many around the world glued to their radios and televisions, Roger Bannister caught up to, and passed, John Landy. The race, later dubbed the Miracle Mile, was featured in the very first issue of *Sports Illustrated*. And suddenly Vancouver was on the sports map of the world.

A few weeks later, on August 28, the BC Lions, who sold 9,000 season tickets for their inaugural season, played the Winnipeg Blue Bombers in their first game at Empire Stadium, with fullback By Bailey scoring the first-ever Lions touchdown.

Facing: Vancouver Sun photographer Charlie Warner captured this famous shot of Roger Bannister (left) and John Landy competing in the one-mile race at the 1954 British Empire Games in Vancouver. Canada's Rich Ferguson placed third. **Copyrighted photo by Charlie Warner**

Above: Pro-Rec, a free government program developed in 1934 to encourage physical fitness, enrolled forty thousand participants in 155 BC centres. **City of Vancouver Archives AM54-S4: Sp P46.5**

Facing: High jumper Shirley Gordon, born with clubfoot, adapted by taking off and landing on the same foot, and competed at the 1948 Olympics and won the 1949 Pacific Northwest and Canadian championships. **BC Sports Hall of Fame**

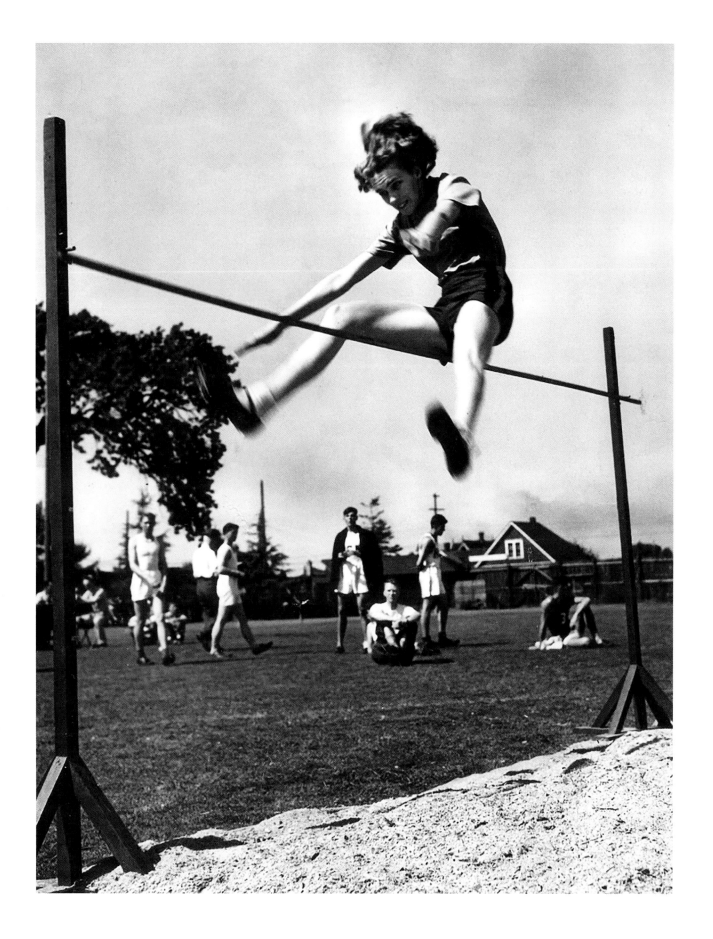

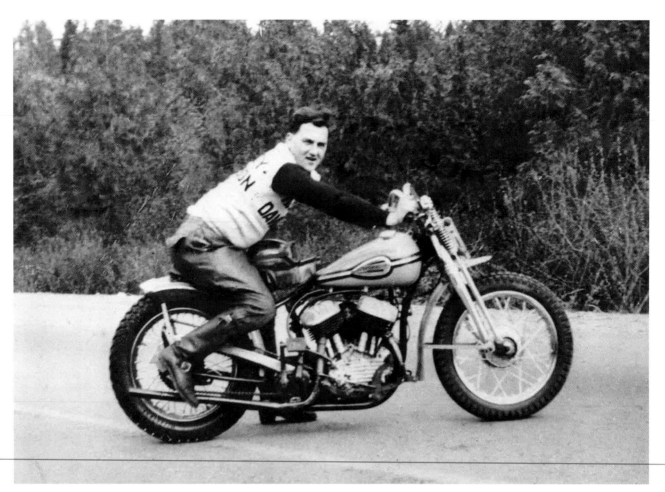

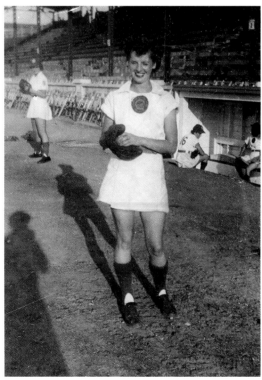

Above: Vancouver's Trev Deeley dominated flat track motorcycle racing in the 1940s and 1950s, and competed in three two-hundred-mile races at Daytona Beach. **Courtesy of the Deeley Exhibition**

Left: Vancouver's Margaret Callaghan was a top infielder for seven seasons with the All-American Girls Professional Baseball League. **BC Sports Hall of Fame**

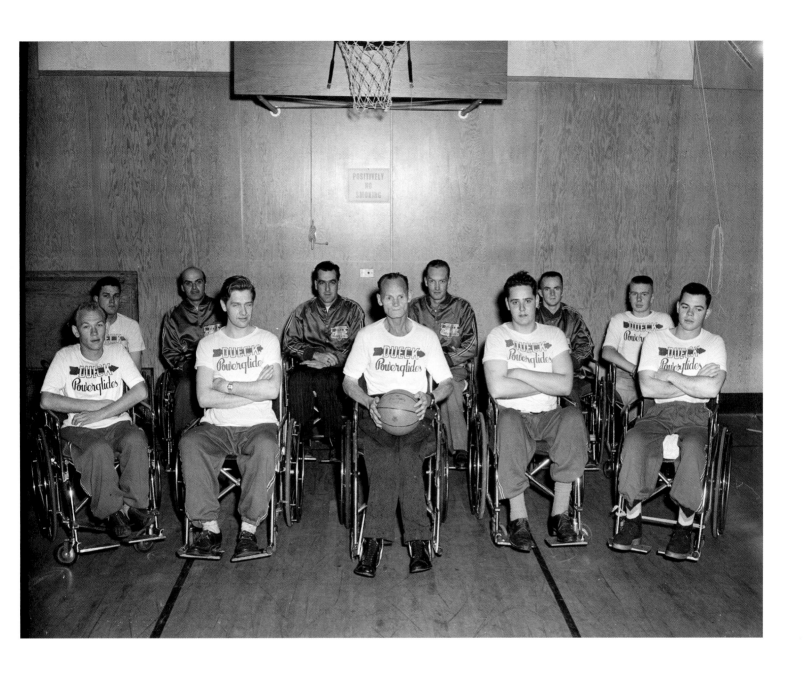

Above: The Dueck Powerglides, BC's first wheelchair basketball team, was established in 1950 by Doug Mowat, Stan Stronge, Jim Mackie, and Walter Schmidt at the Western Rehabilitation Centre.

Vancouver Public Library 84597B

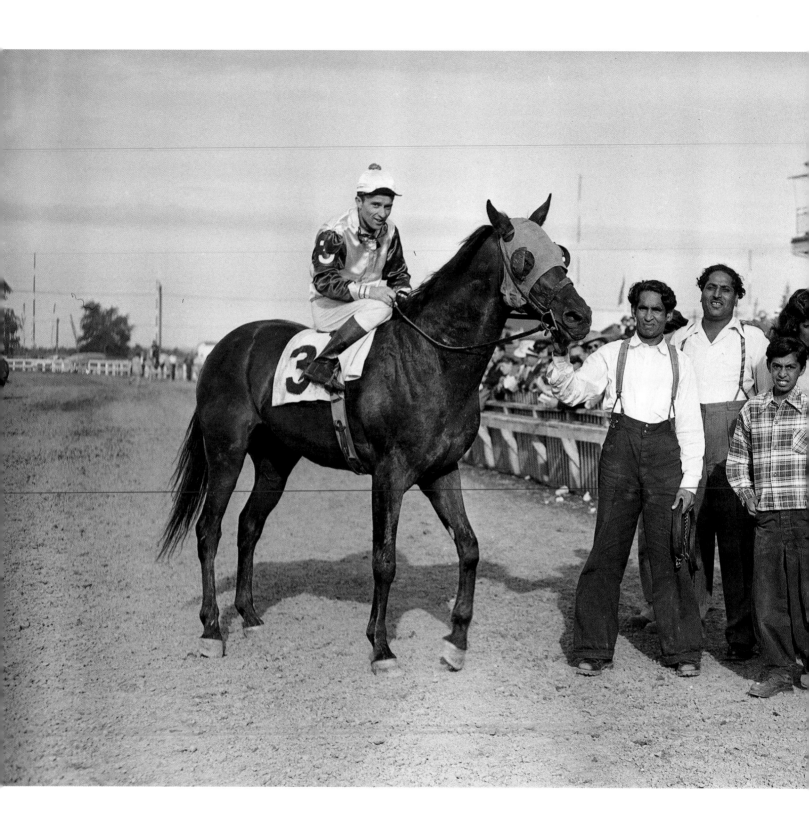

Above: Owner and breeder Banto Betty Gill (wearing glasses), jockey Henry Matthews, and horse Lou Gallator at Richmond's Lansdowne Park in 1952. **Vancouver Public Library 84643i**

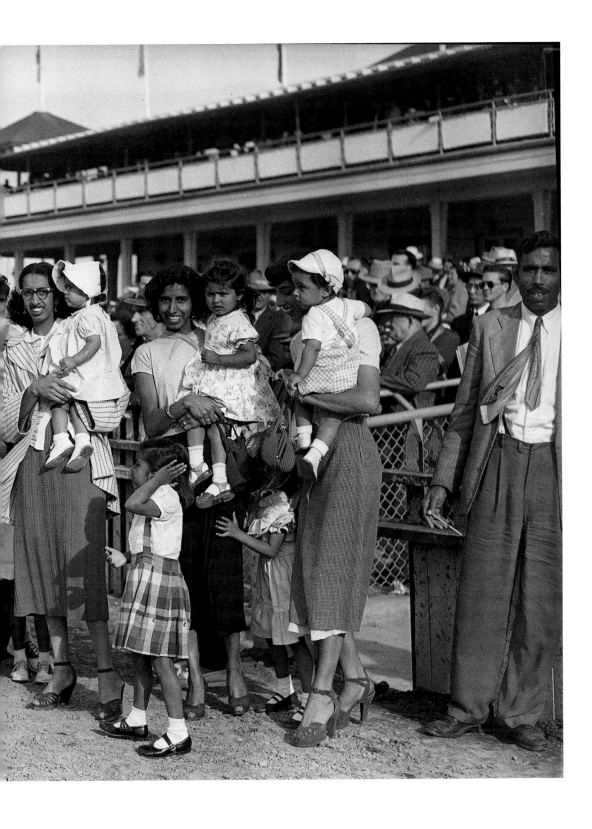

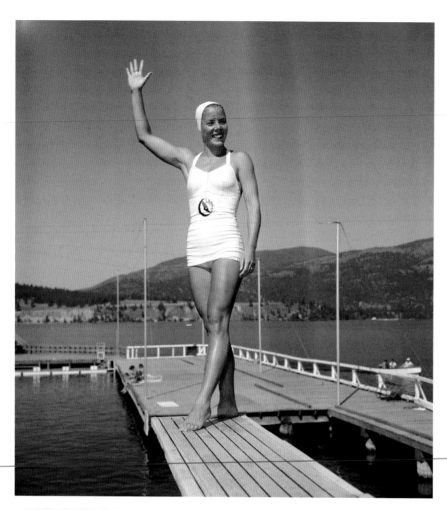

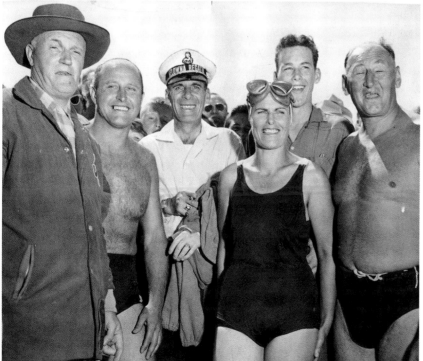

Left top: Irene MacDonald, pictured at the Kelowna Aquatic Centre, won bronze (1954) and silver (1958) at the British Empire Games, and bronze at the 1956 Olympics. **Vancouver Sun**

Left bottom: Ann Meraw's marathon swims included a 34.6-mile swim in 1958 in Okanagan Lake from Kelowna to Penticton in 32.5 hours. From left, coach Pat Roach, John Jaremy, husband Joseph, son Bill, unknown man. **Bill Cunningham/*Province***

Facing: George Athans, pictured (bottom) with Al Patnik at the 1944 Kelowna Regatta, won ten Canadian diving titles, competed at the Olympics (1936, 1948), and coached diving. **Dave Buchan/*Vancouver Sun***

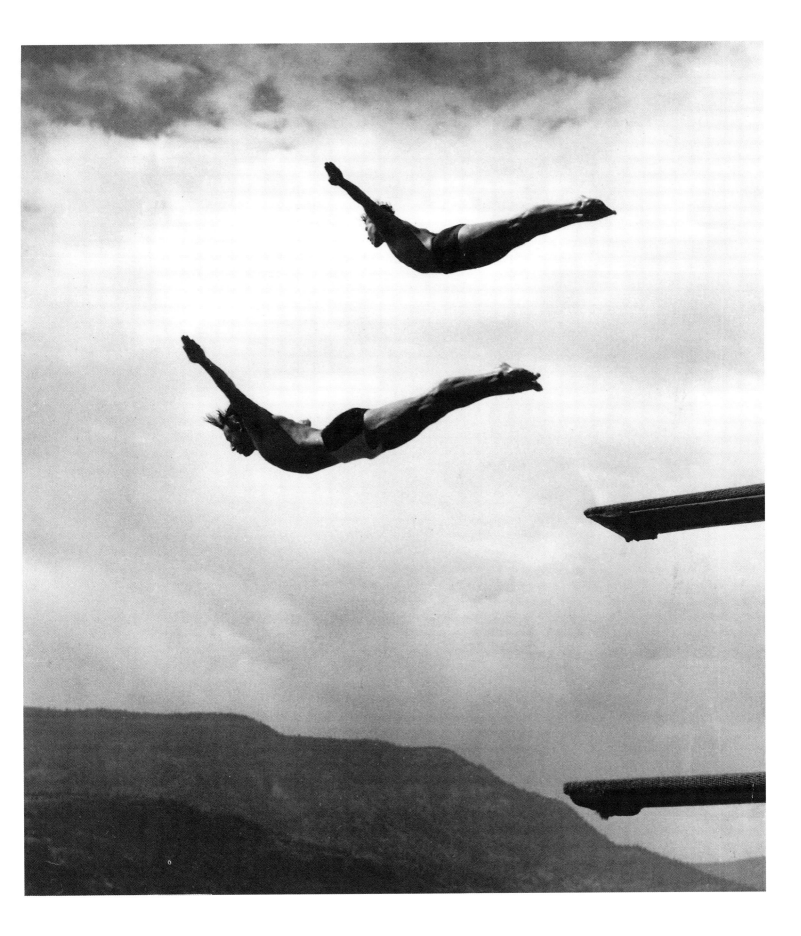

Above left: Vancouver's Ruth Wilson won tennis and basketball championships, played softball, was a top golfer and basketball coach, and wrote a women's sports column for the *Sun*. **Province**

Above right: Ted Hunt, pictured (right) in 1958 with hockey star Maurice Richard, excelled in rugby, boxing, skiing, ski jumping, and played with the BC Lions and the Vancouver Burrards lacrosse team. **Bob Olsen/Province**

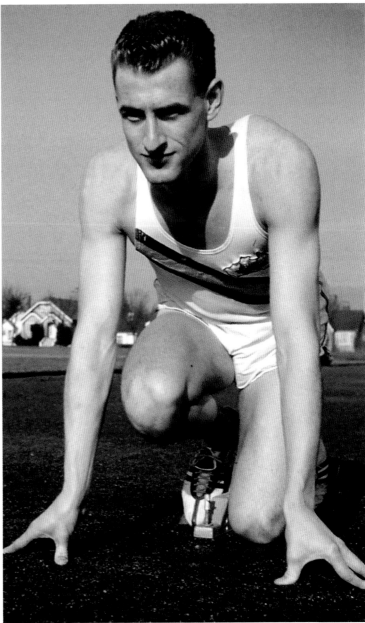

Above: Diane and Doug Clement founded the Kajaks Track and Field Club and the Vancouver Sun Run. Diane won bronze at the 1958 British Empire Games, and was the first female coach of UBC's track team. Doug won silver at the 1954 British Empire Games and was a sports medicine pioneer and the Canucks team physician for seven years. **Photos courtesy of Diane and Doug Clement**

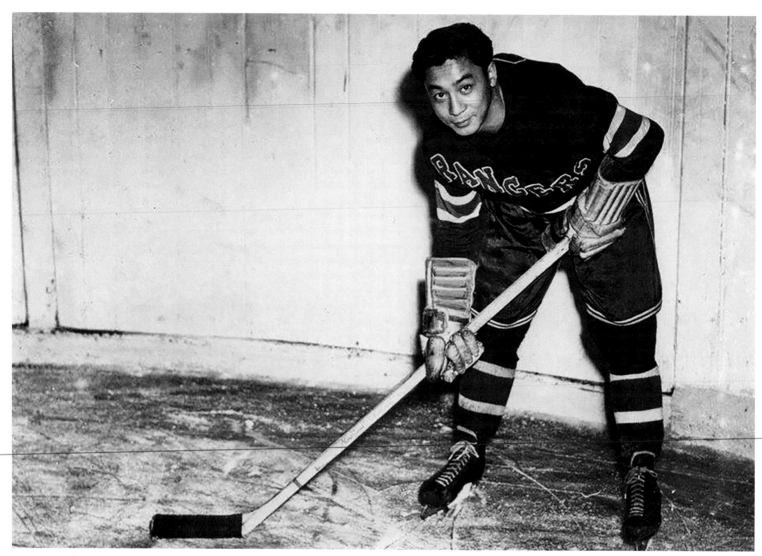

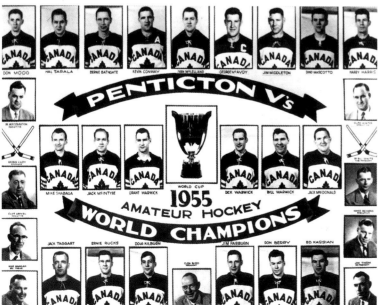

Above: Vernon's Larry Kwong played for the Vernon Hydrophones, the Trail Smoke Eaters, and, after a 1948 shift with the New York Rangers, became the first Asian to play in the NHL. **BC Sports Hall of Fame**

Left: In 1955, the Penticton Vees won the World Hockey Championship: Bernie Bathgate, Don Berry, Kevin Conway, Jim Fairburn, Harry Harris (trainer), Ed Kassian, Doug Kilburn, George McAvoy, Jack MacDonald, Jack McIntyre, Ivan McLelland, Jim Middleton, Don Moog, Dino Moscotto, Ernie Rucks, Mike Shabaga, George Stoll (trainer), Jack Taggart, Hal Tarala, Bill Warwick, Dick Warwick, Grant Warwick (player-coach). **BC Sports Hall of Fame**

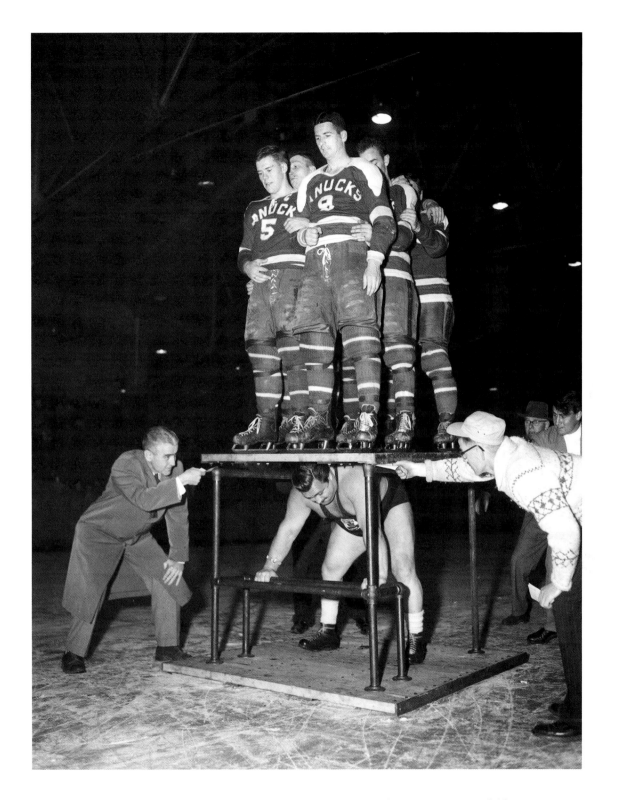

Above: Vancouver weightlifter Doug Hepburn, pictured lifting six Canucks players in 1954, won the 1953 World Heavyweight title and gold at the 1954 British Empire Games. **Roy LeBlanc/*Vancouver Sun***

Above: A 1950 event at Vancouver's Kitsilano Beach featured ski jumping, swimming, and diving demonstrations at Kits Pool and yacht races and water skiing in English Bay. **Vancouver Sun**

Facing top: Over 100,000 kids took Vancouver Sun free swim classes at Lower Mainland and Vancouver Island pools, 1932–74, including at Lumberman's Arch Pool (pictured in the 1950s). **Vancouver Sun**

Facing bottom: Over 50,000 students of all ages attended the Vancouver Sun free ski school, 1950–65, which offered lessons on Grouse Mountain and a bus ride from downtown. **Vancouver Sun**

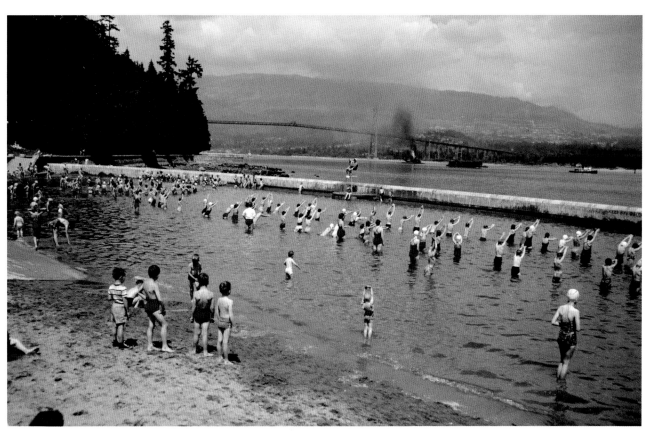

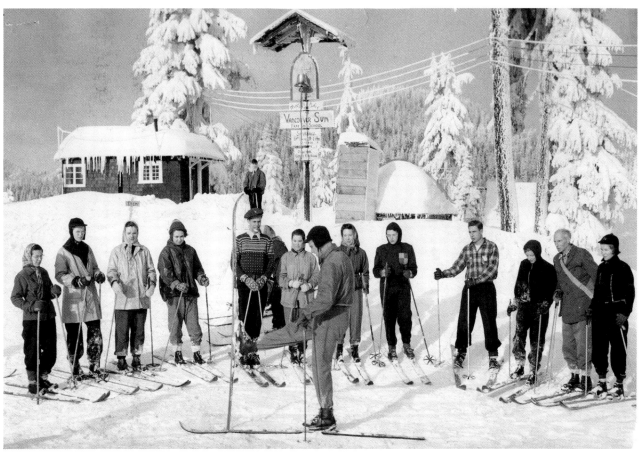

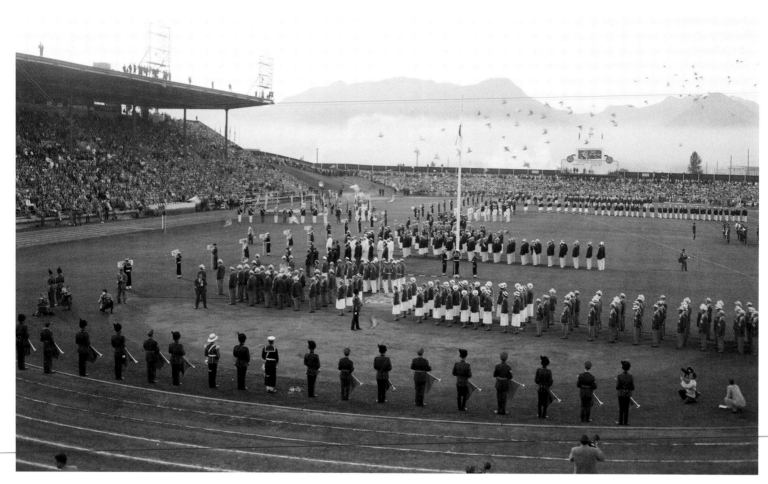

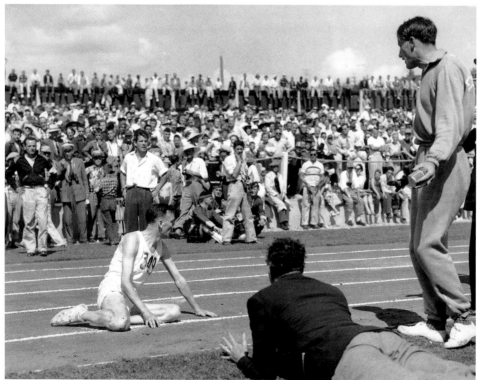

Above: At the opening of the British Empire Games on July 30, 1954, at Empire Stadium, 652 athletes from twenty-four countries marched before 29,350 spectators. **Charlie Warner/*Vancouver Sun***

Left: When English marathoner Jim Peters entered Empire Stadium in first place at the 1954 British Empire Games, he collapsed several times before having to stop short of the finish. ***Province***

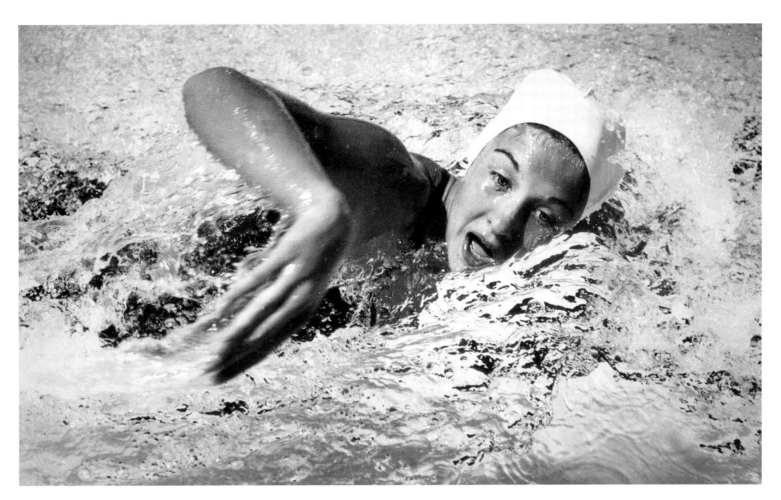

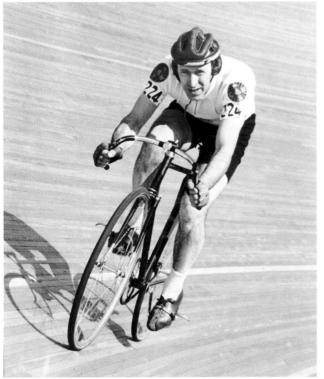

Above: Vancouver's Helen Stewart won silver at the 1954 British Empire Games, gold and two silvers at the 1955 Pan Am Games, and competed at the 1956 Olympics. **Bill Cunningham/*Province***

Left: Vancouver cyclist Lorne "Ace" Atkinson competed at the 1954 British Empire Games, coached, organized events, and promoted the sport. **Photo courtesy of the Atkinson Family**

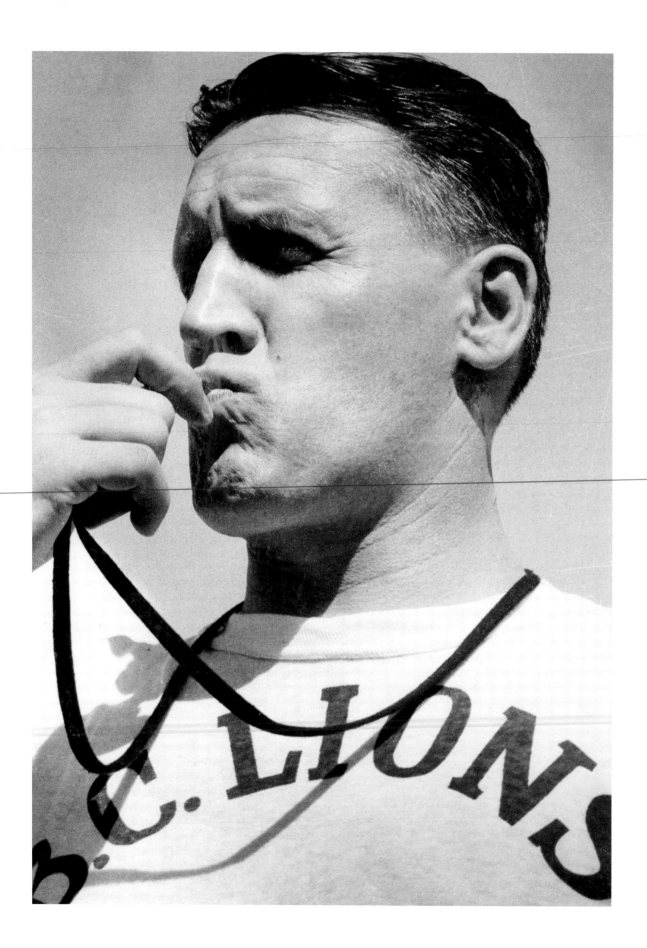

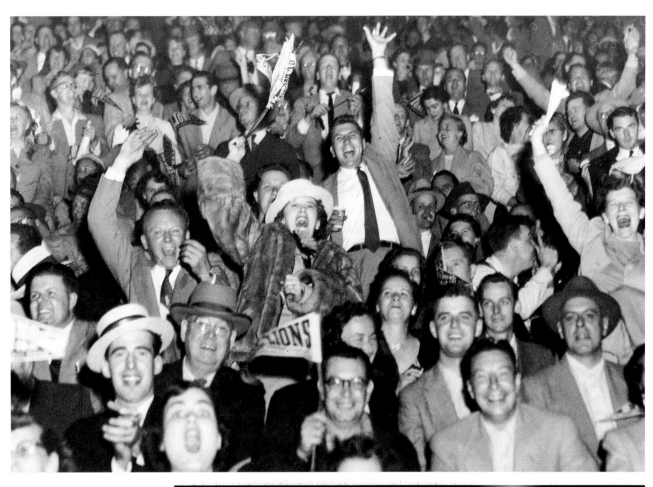

Facing: Annis Stukus, who had played and coached for the Toronto Argonauts and Edmonton Eskimos, helped found the BC Lions and served as the team's first head coach and GM. *Vancouver Sun*

Above: At the first BC Lions game, on August 28, 1954, against the Winnipeg Blue Bombers at Empire Stadium, 20,606 fans cheered for their new team. **Bill Dennett/***Vancouver Sun*

Right: By Bailey scored the BC Lions' first-ever touchdown in the second quarter of the Lions' first game. **Brian Kent/** *Vancouver Sun*

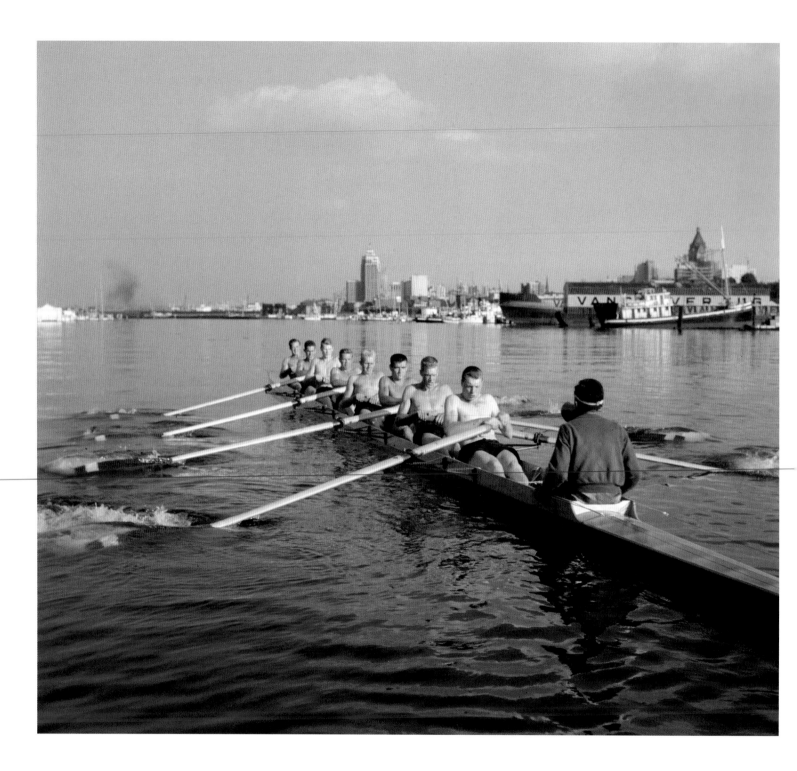

Above: The UBC/Vancouver Rowing Club eights, pictured in Vancouver's Coal Harbour, won silver at the 1956 Olympics. From left: Phil Kueber, Dick McClure, Bob Wilson, Dave Helliwell, Waynne Pretty, Bill McKerlich, Doug McDonald, Laurie West, Carl Ogawa. **Charlie Warner/ Vancouver Sun**

Facing: Chief Dan George of the Tsleil-Waututh Nation, Oscar-nominated actor in Little Big Man and champion canoe racer, pictured in 1954 with the 1936 Vancouver Golden Jubilee International Indian War Canoe Championship trophy. **Vancouver Sun**

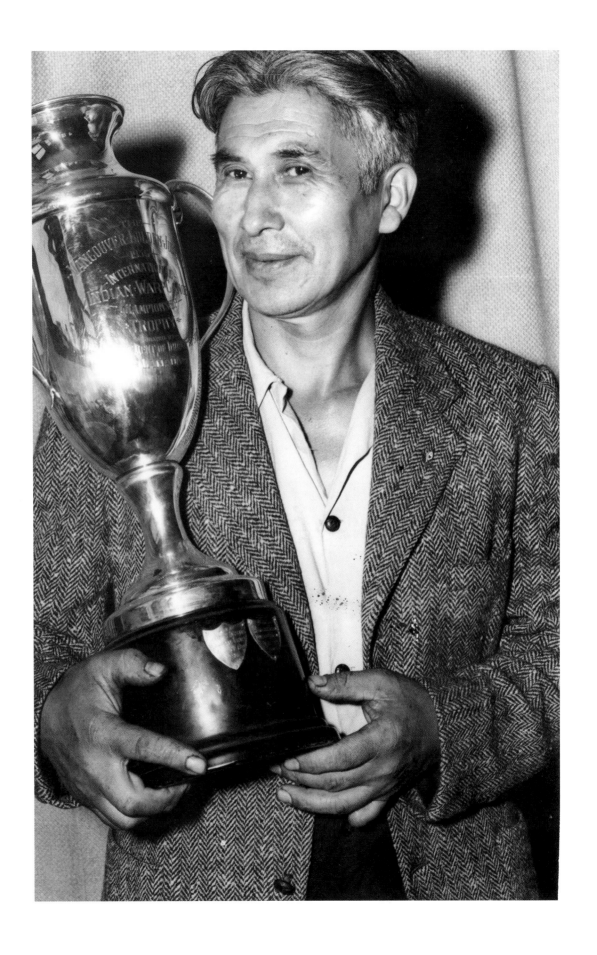

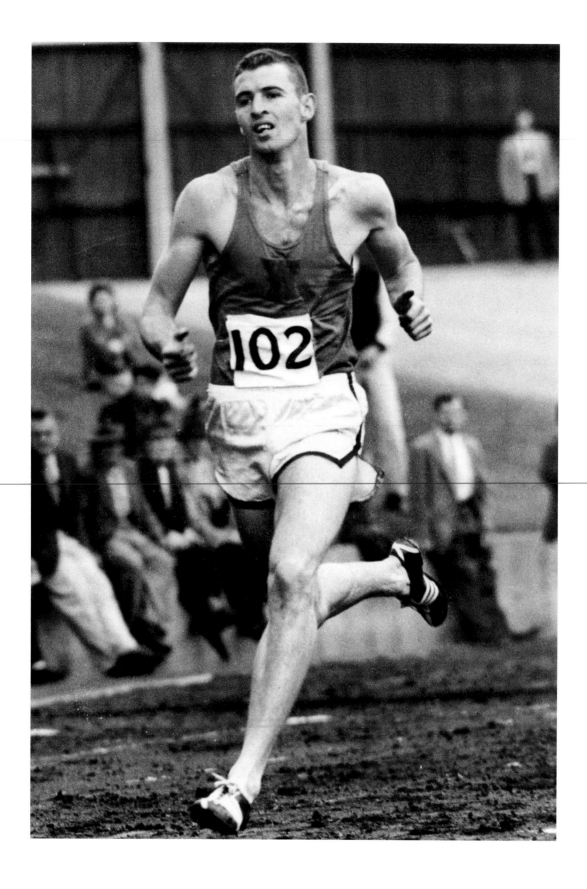

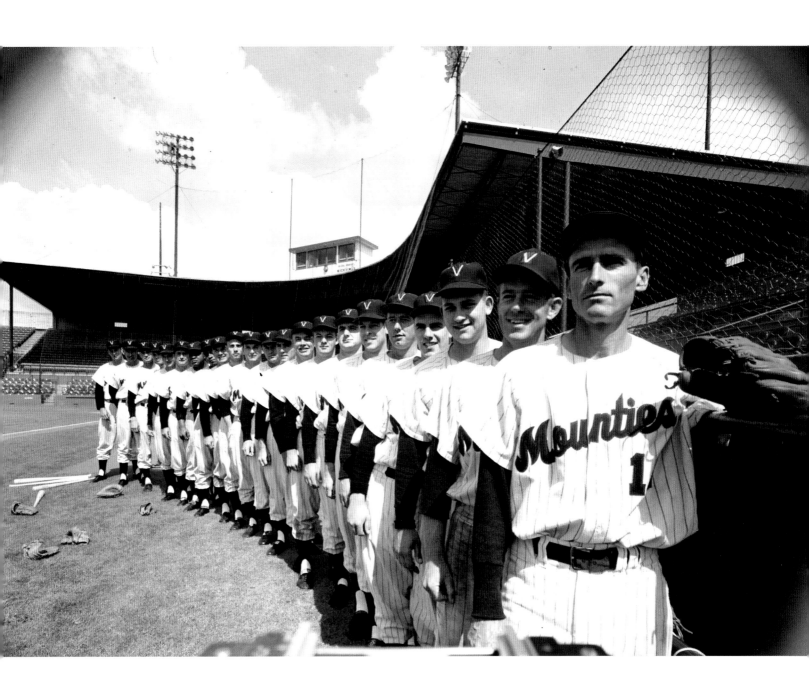

Facing: Cumberland sprinter Terry Tobacco won bronze and silver at the 1954 British Empire Games, and bronze in the 440-yard race at the 1958 British Empire Games. **Brian Kent/*Vancouver Sun***

Above: The Vancouver Mounties of the Pacific Coast League at Capilano Stadium, now Nat Bailey Stadium, in 1958. From left, Gord Sundin, Bill Hain, Russ Heman, Barry Shetrone, Mel Held, Erv Pelica, Charlie White, Joe Durham, Owen Friend,

Dave Jordan, Jim Brideweser, Joe Frazier, Jerry Lane, Joe Hatten, Ron Moeller, Art Ceccarelli, Bill Lajoie, George Bamberger, Tommy Hatton, Ray Barker, Buddy Peterson, and player-coach Spider Jorgensen. **Charlie Warner/*Vancouver Sun***

Above: Valerie Jerome, pictured at the 1959 Vancouver high school track meet, won bronze on the 4x100-metre relay team at the 1959 Pan Am Games and competed at the 1960 Olympics. **John Askew/***Vancouver Sun*

Facing: Westwood Racing Circuit opened in 1959. It hosted several pro race series, featuring drivers such as Gilles Villeneuve and Michael Andretti, before closing in 1990. **Don LeBlanc/***Vancouver Sun*

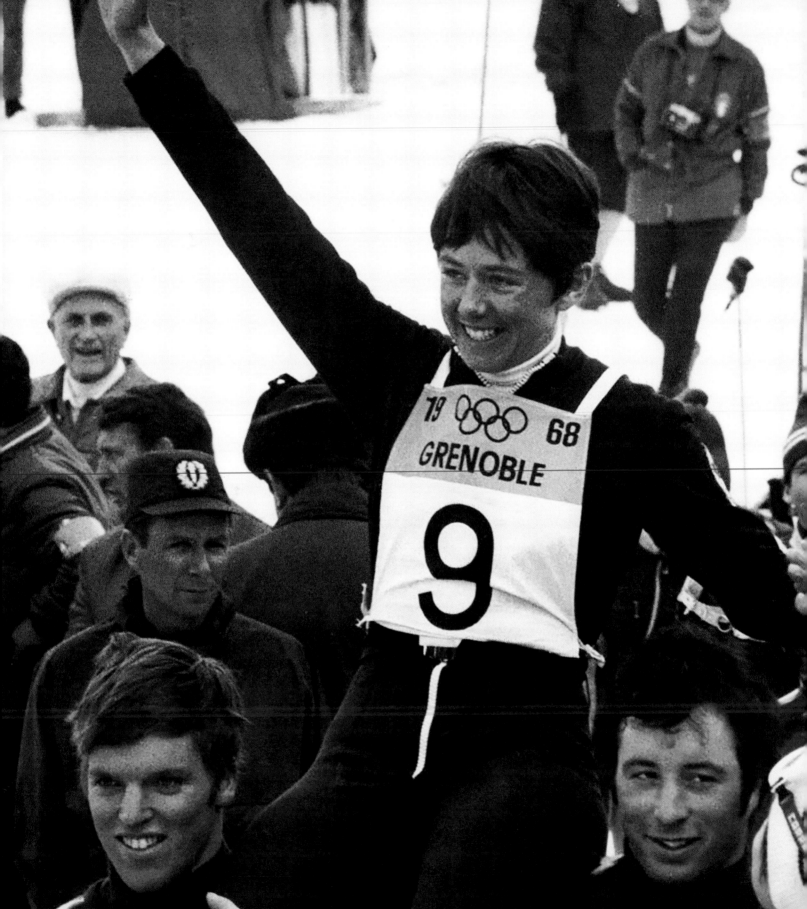

1960s

OVER THE YEARS, female athletes faced the challenge of societal attitudes regarding vigorous exercise for women, particularly the stance against women participating in competitive sports. "Women have but one task," said Pierre de Frédy, Baron de Coubertin, founder of the modern Olympic Games, "that of crowning the victor with garlands. In public competitions, women's participation must be absolutely prohibited. It is indecent that spectators would be exposed to the risk of seeing the body of a woman being smashed before their eyes."

Despite a lack of access to equipment, facilities, coaching, and funding, women sought out and found opportunities to not only participate in sports, but to become world class athletes.

In the 1960s, female athletes from British Columbia began to dominate in world competition. Vancouver swimmer Elaine Tanner, nicknamed "Mighty Mouse," was only fourteen when she burst onto the scene at the 1965 Canadian Swimming Championships in Red Deer, Alberta. She won four gold and three silver medals at the 1966 Commonwealth Games in Jamaica, and set two Games records. At the 1967 Pan American Games in Winnipeg, Tanner won two gold and two silver medals and set two world records, and at the 1968 Olympics in Mexico she earned two silver medals and a bronze.

Nancy Greene was known for her fearless and aggressive skiing style. The citizens of her home town of Rossland raised funds to enable her to train and compete in Europe, and she was one of the first female athletes to do serious weight training. With her nickname, "Tiger," adorning her helmet, Greene won the World Cup in 1967 and 1968. At the 1968 Winter Olympics in Grenoble, Greene won two of Canada's three medals at the Games, gold in giant slalom and silver in slalom. At her homecoming parade, Greene told the crowd, "If you want to do something, if you have a goal and stick to it, you can make it ... and when you have done it, it is a wonderful feeling."

Facing: Rossland's Nancy Greene was carried by Canadian skiers Bob Swan and Bill McKay after winning a gold medal in giant slalom at the 1968 Olympics. In 1999, Greene was voted Canada's Female Athlete of the 20th Century. **H.J. Leclair, Library & Archives Canada, e011196808_s1**

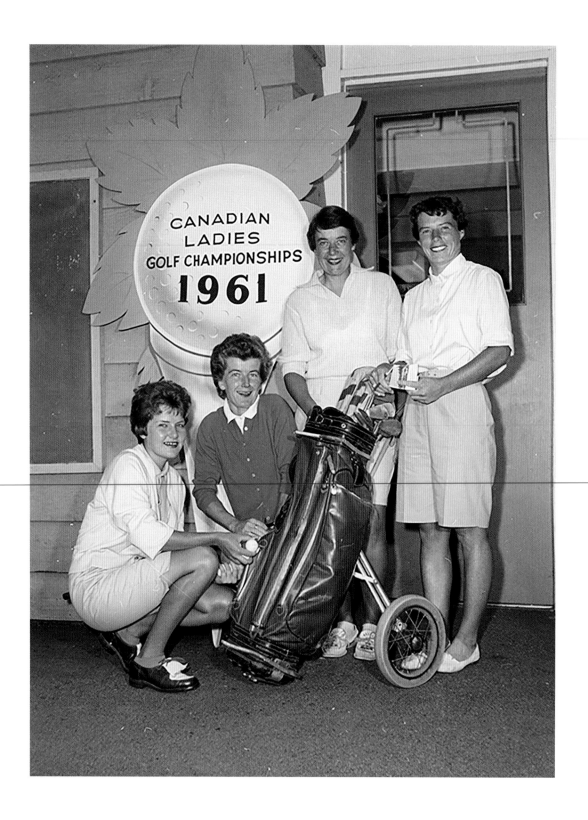

Above: The BC team, from left, Gayle Hitchens, Colleen Smith, Ruth Wilson, and Janet McWha, won the 1961 Canadian Ladies Golf championships at Marine Drive Golf Club. **George Diack/*Vancouver Sun***

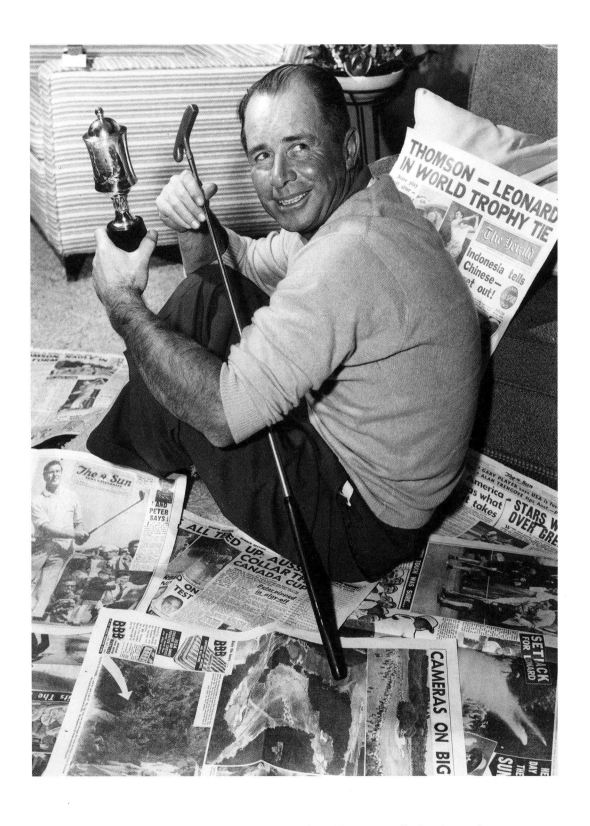

Above: Vancouver golfer Stan Leonard had forty-two professional career wins, and won three PGA Tour events, including the 1960 Western Open. **Brian Kent/** *Vancouver Sun*

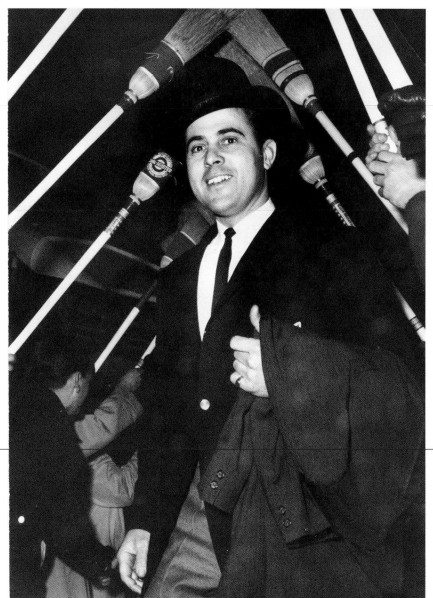

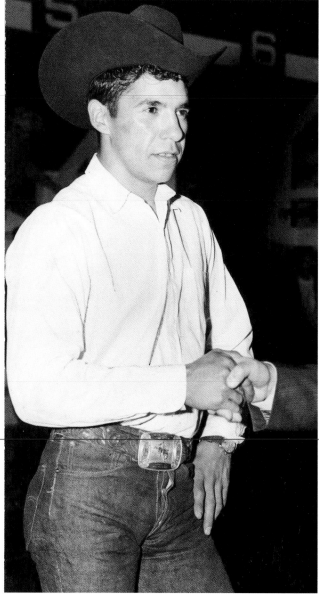

Above left: In 1961, Lyall Dagg (pictured), Leo Herbert, Fred Britton, and Barry Naimark won the Macdonald Brier (Canada) and the Scotch Cup (world) curling championships. **Ken Oakes/***Vancouver Sun*

Above right: Indigenous rodeo star Kenny McLean from Okanagan Falls was the 1961 International Rookie of the Year and the 1962 saddle bronc riding world champion. *Vancouver Sun*

Facing: Danny Sailor, the first Canadian to win the tree climbing world title in 1962, scaled and descended a 110-foot tree in 37.4 seconds. Pictured at the Squamish Days Loggers Sports Festival in 1962. **Ralph Bower/***Vancouver Sun*

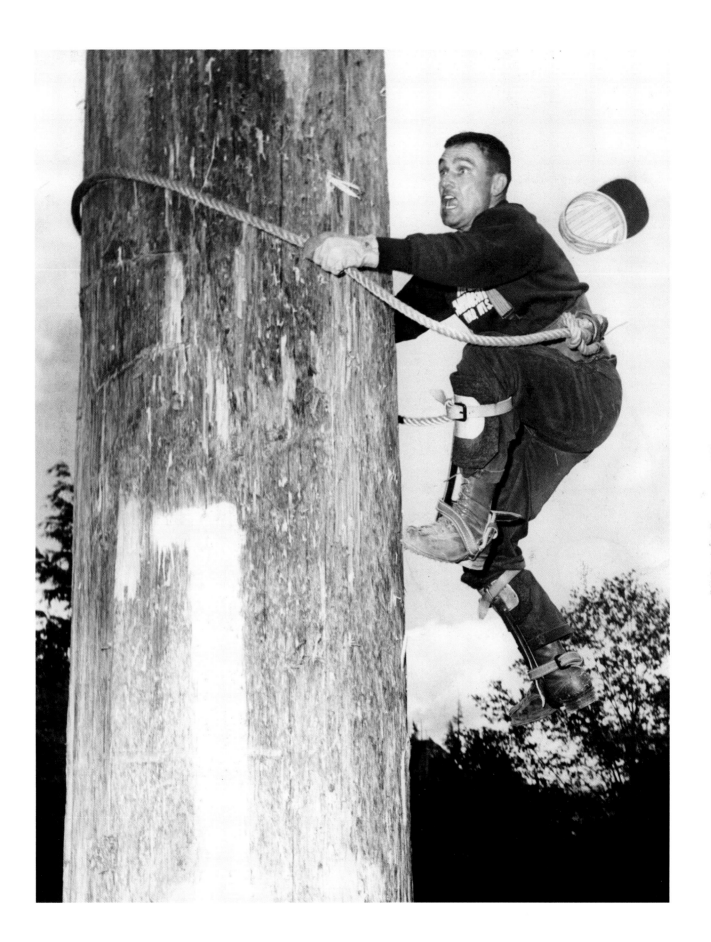

Facing: Kelowna's Greg Athans, pictured in 1966, later won eight national water ski titles and over twenty World Cup and world championship freestyle skiing titles. **Bill Cunningham/*Province***

Above: The Nanaimo to Vancouver bathtub race, pictured in 1968, was an annual event at the Vancouver Sea Festival, 1967–97. **Ken Oakes/*Vancouver Sun***

Above: In 1964, the BC Lions won their first Grey Cup after Bill Munsey (pictured with wife Rosemary) scored two touchdowns in the third quarter. **Ralph Bower/** *Vancouver Sun*

Facing: Bob Ackles (pictured in 1963) began in 1953 as a BC Lions water boy, was GM 1975–86, and Lions CEO and president from 2002 until his death in 2008. **Dan Scott/***Vancouver Sun*

Left: Vancouver's Doug Rogers won silver in heavyweight judo at the 1964 Olympics, bronze at the 1965 World Judo Championships, and gold at the 1965 and 1967 Pan Am Games. ***Vancouver Sun***

Facing: Vancouver's George Hungerford (right) and Roger Jackson won gold at the 1964 Olympics, and Hungerford won gold with the UBC/Vancouver Rowing Club eights at the 1964 Royal Canadian Henley. **BC Sports Hall of Fame**

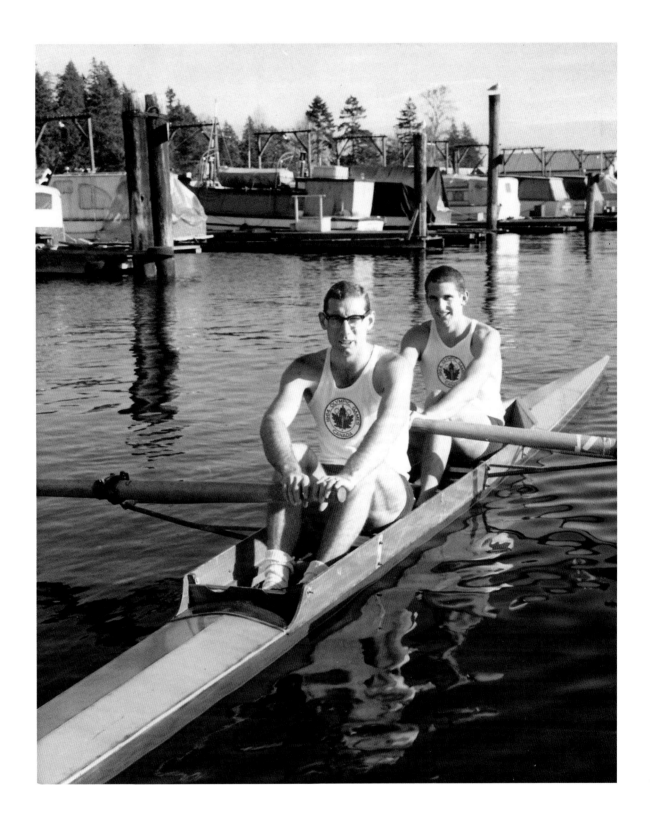

Above: On May 27, 1959, North Vancouver's eighteen-year-old Harry Jerome (left) ran the 220-yard race in 21.9 seconds, breaking the Canadian high school record set by Vancouver's Percy Williams (right) in 1928. **Province**

Facing: Jerome overcame a potential career-ending injury to win bronze in the 100-metres at the 1964 Olympics, and won gold at the 1966 British Empire and 1967 Pan Am Games. Pictured is Jerome competing at the BC track championships and Olympic trials in July 1964 at Brockton Oval in his University of Oregon T-shirt, which he wore inside out to protest racism. **Ken Oakes/*Vancouver Sun***

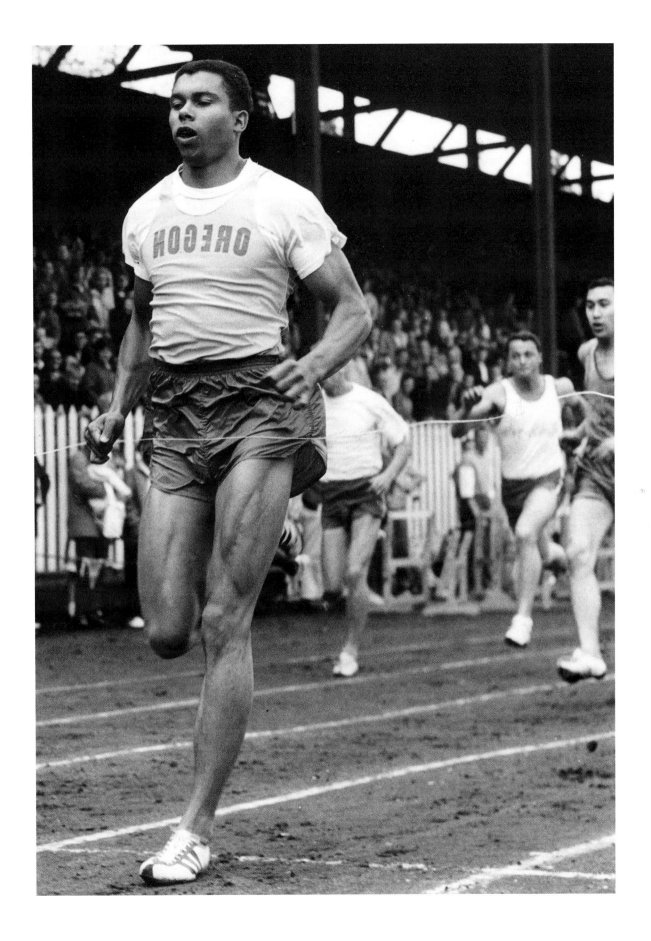

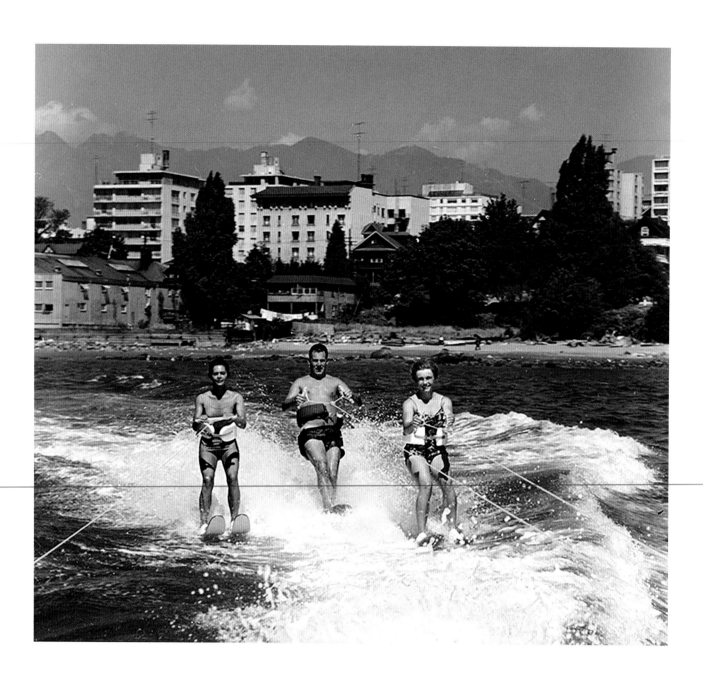

Facing: A water skiing demonstration in Vancouver's English Bay on August 1, 1961. **Ray Allan/***Vancouver Sun*

Above: This 1967 publicity photo for the Pacific Coliseum, opened in 1968, included curler Lyall Dagg, sprinter Harry Jerome, figure skater Karen Magnussen, the Canucks' Barry Watson, boxer Dick Findlay, wrestler Don Leo Jonathan, and basketball player Ron Thorsen. **City of Vancouver Archives 180-5854**

Above: Athletes en route to the 1968 Olympics in Mexico City. BC swimmers Elaine Tanner, Ralph Hutton, and Marion Lay (4x100-metre freestyle relay) won four of Canada's five medals. **Dave Looey/** *Province*

Above: Elaine Tanner won seven medals at the 1965 Commonwealth Games and won two golds and set record times at the 1967 Pan Am Games. **Bill Cunningham/** *Province*

Right: At the 1968 Olympics, Ocean Falls swimmer Ralph Hutton won silver in 400-metre freestyle, and West Vancouver's Elaine Tanner won two silvers and a bronze. **Bill Cunningham/***Province*

1970s

ON OCTOBER 9, 1970, the Vancouver Canucks played their season-opening game as a National Hockey League expansion franchise against the Los Angeles Kings to a near-capacity crowd at the Pacific Coliseum.

It was a historic night in Vancouver sports history, with British Columbia Premier W.A.C. Bennett and NHL president Clarence Campbell in attendance for the opening ceremonies. Special guests included Chief Dan George, who starred in the recently completed film *Little Big Man*, and Fred "Cyclone" Taylor from the 1915 Stanley Cup–winning Millionaires. The Canucks lineup included captain Orland Kurtenbach, Pat Quinn, Dale Tallon, Rosaire Paiement, Andre Boudrias, Murray Hall, and Wayne Maki.

The Stanley Cup was displayed at centre ice, and Vancouver mayor Tom Campbell stooped to kiss it, perhaps jinxing the Canucks' puck luck to this day. "Tom Terrific" also won the first ceremonial faceoff against federal public works minister Arthur Laing. The enthusiastic crowd booed Mayor Campbell, but then they always booed Campbell.

Canadian singing star Juliette sang "O Canada," and Vancouver-born referee Lloyd Gilmour dropped the puck to start the game. Defenceman Barry Wilkins scored the first goal at 2:14 of the third period, but the Canucks lost 3–1. *Vancouver Sun* sports editor Duncan Stewart ended his report of the game, "and as the 15,062 filed out, there were the first grumblings of a winter of discontent."

In Greg Douglas and Grant Kerr's book *Canucks at Forty*, Orland Kurtenbach is quoted as saying, "sure it would have been great to win a few more games for the fans in the early 1970s. But they loved us for what we were and we loved them back."

And our fervent and sometimes dysfunctional love affair with the Vancouver Canucks was underway.

Facing: Prior to the Vancouver Canucks' first game as an NHL expansion franchise against the Los Angeles Kings on October 9, 1970, Hockey Hall of Fame curator Maurice Reid (left) displayed the Stanley Cup at centre ice, and Vancouver mayor Tom Campbell kissed it. **Brian Kent/***Vancouver Sun*

Above: The first captain of the Canucks, Orland Kurtenbach, pictured in 1970, retired from playing in 1974, and was the team's head coach, 1976–78. **Deni Eagland/***Vancouver Sun*

Facing: Canadian boxer George Chuvalo (left) lost in a twelve-round unanimous decision to heavyweight champion Muhammad Ali at the Pacific Coliseum in 1972. **Ralph Bower/***Vancouver Sun*

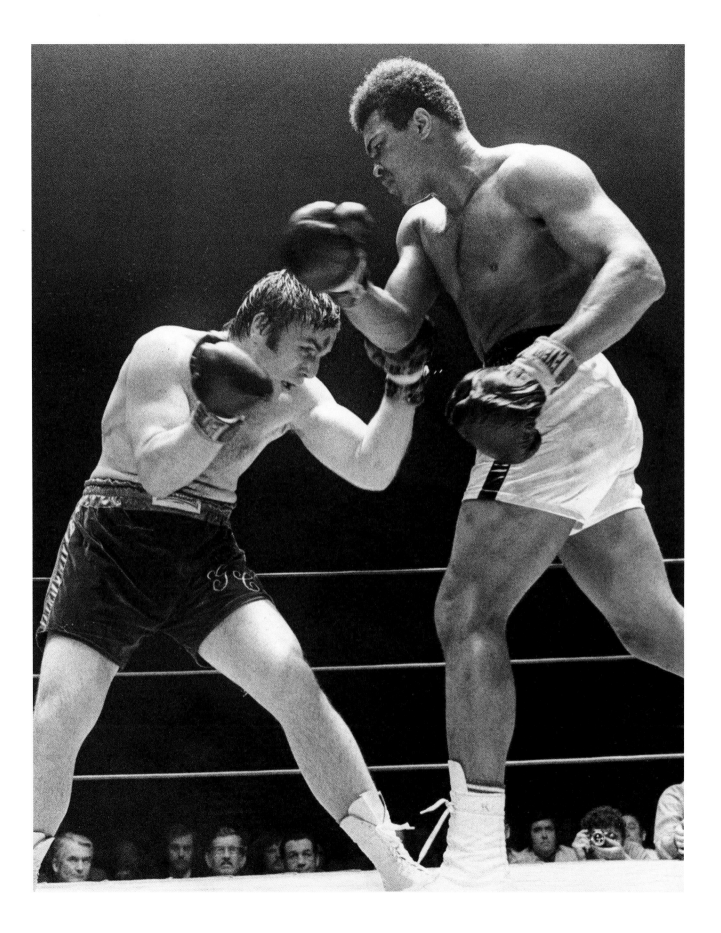

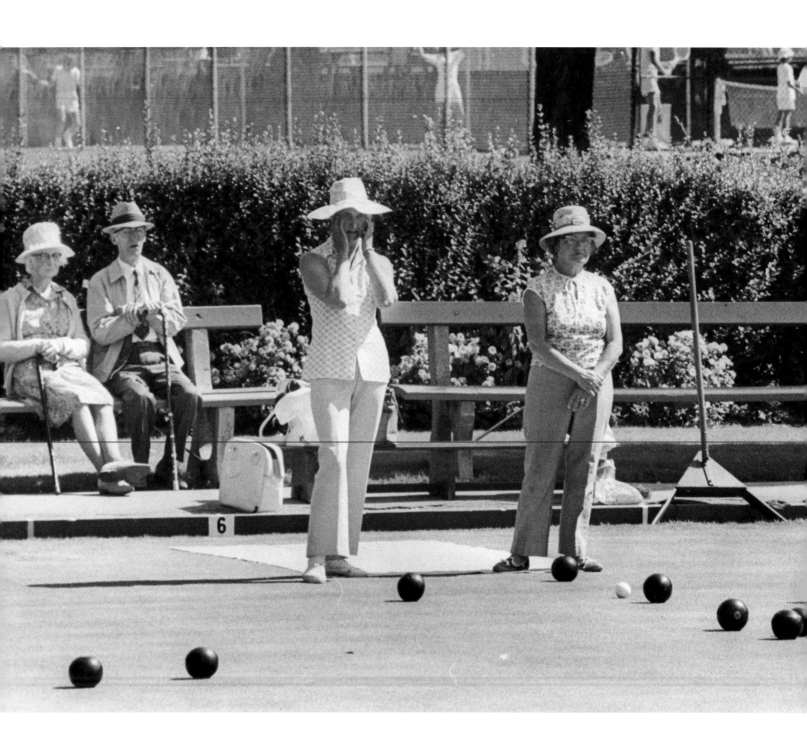

Above: A few of the two hundred members of the Stanley Park Lawn Bowling Club practising for an upcoming competition in August 1972. **Ralph Bower/*Vancouver Sun***

Facing: Patricia Loveland (right) was the female winner and Surrey's Tim Howard the male winner at the first Vancouver Marathon around Stanley Park in 1972. **Ray Allan/*Vancouver Sun***

Above: After Vancouver fans booed a Canadian loss in the 1972 Soviet–Canada Summit series, Phil Esposito (7) told media the team tried their best. Canada's Paul Henderson scored the series-winning goal in Moscow. **Ken Oakes/***Vancouver Sun*

Facing: Abbotsford's Eugene Reimer (20) won ten Paralympic and fifty Canadian and Pan Am medals, and in 1972 was the first disabled person awarded Sport Canada's Norton H. Crow Award for Male Athlete of the Year. **Dan Scott/***Vancouver Sun*

Facing: North Vancouver figure skater Karen Magnussen won Canada's only medal, a silver, at the 1972 Olympics, and won the 1973 World Championships. **Ken Oakes/*Vancouver Sun***

Above: Vancouver high jumper Greg Joy, pictured at the 1974 Vancouver high school track meet, won silver in high jump at the 1976 Olympics, the highest medal earned by Canada in Montreal. **Glenn Baglo/*Vancouver Sun***

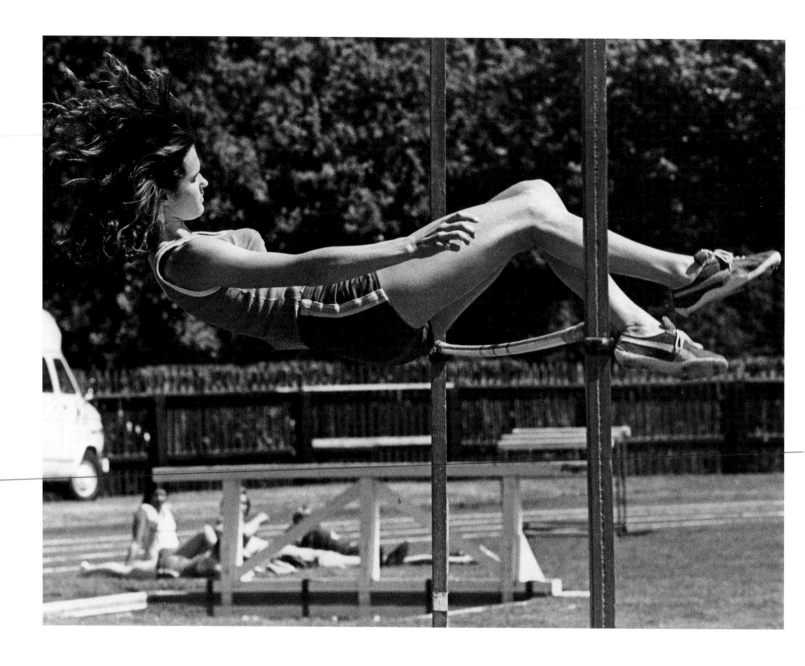

Above: Maple Ridge's Debbie Brill, the first North American woman to clear six feet, won sixty-five national and international high jump championships, and was named BC's Athlete of the Decade for the 1970s. **Colin Price/***Province*

Facing left: Vancouver ice dancers Louise and Barry Soper won four golds at the Canadian Championships, 1971–74, competed at four World Championships, and won silver at the 1973 Skate Canada. **Bill Cunningham/***Vancouver Sun*

Facing right: Victoria's Philip Delesalle, pictured at the 1975 BC championships at SFU, won the Canadian championships, 1976–80, and two golds at the 1978 Commonwealth Games. **Ralph Bower/** *Vancouver Sun*

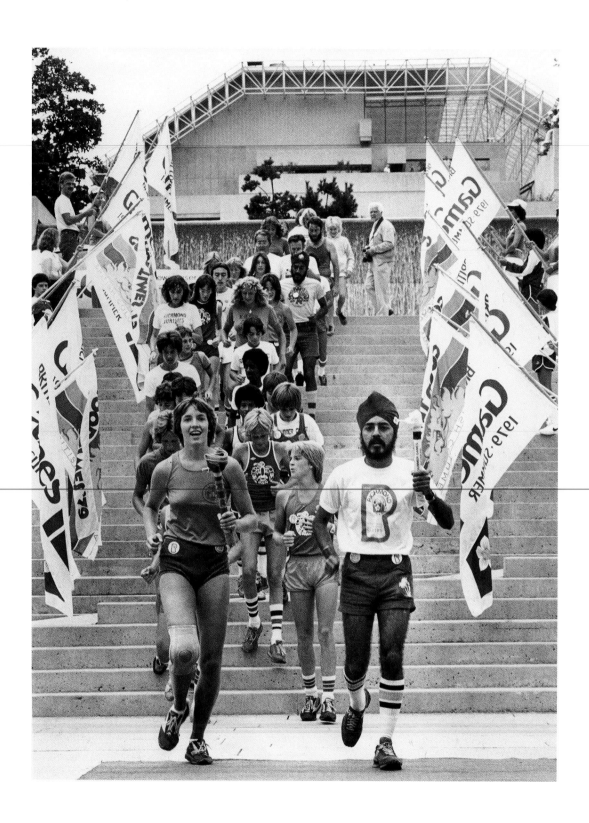

Above: Athletes kick off the 1979 BC Summer Games, which have run annually since 1978. The first annual BC Winter Games were held in 1979. **Wayne Leidenfrost/Province**

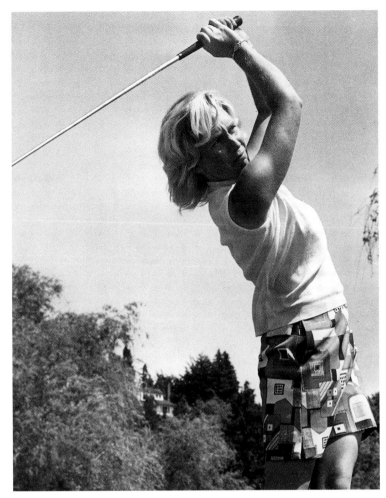

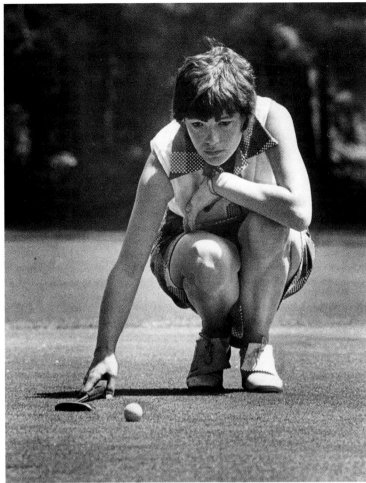

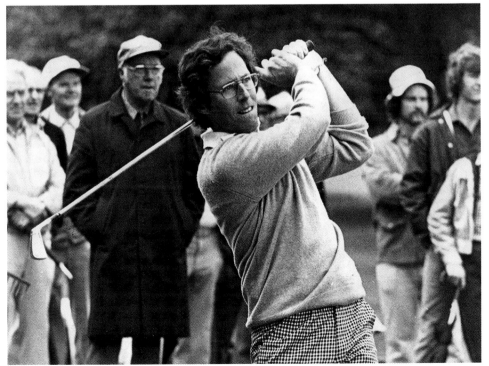

Above left: Vancouver's Marilyn Palmer was 1973 Pacific Northwest Golf champion, won nine BC amateur titles, and played on the winning 1979 Commonwealth team. **Bill Cunningham/*Province***

Above right: Vancouver's Gail Harvey Moore won the BC and Canadian Ladies Amateur championships in 1970, and played on the winning 1979 Commonwealth team. **Ian Lindsay/*Vancouver Sun***

Left: Vancouver's Doug Roxburgh won a record thirteen BC Amateur championships, and four Canadian Amateur titles (1972, 1974, 1982, 1988). **Dave Paterson/*Province***

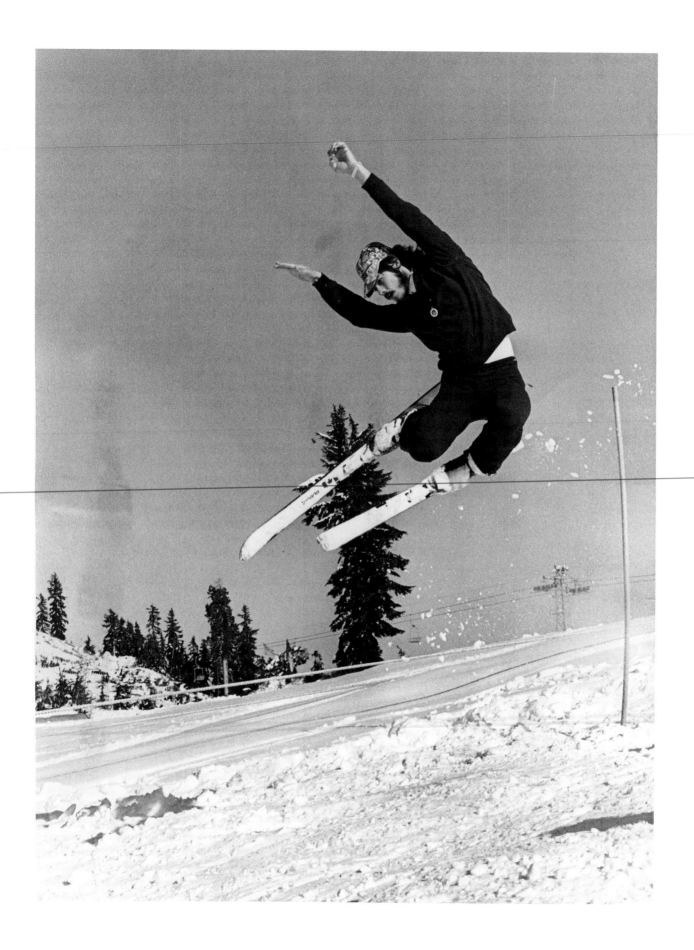

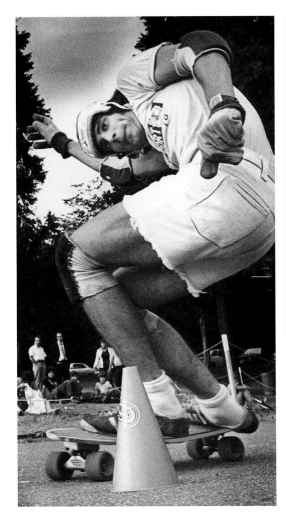

Facing: Freestyle skiing, or "hotdogging," pictured at Grouse Mountain in 1972, began in the 1960s, and the Canadian Freestyle Skiers Association was formed in 1974. ***Province***

Above left: North Vancouver's Ted Hartley, captain of the BC skateboard team, at Stanley Park in 1978. **Ross Kenward/ *Province***

Above right: Vancouver's Edward McVicker in 1976 performing a poor man's version of stuntman Evel Knievel clearing ten Mack trucks on a motorcycle. **Dave Paterson/ *Province***

Above: The New Westminster Bruins junior hockey team won the 1977 Memorial Cup, a feat they repeated in 1978. *Province* photographer Colin Price pictured at right. **Ralph Bower/*Vancouver Sun***

Facing: Australian all-time fastest cricket bowler Jeff Thomson helping defeat the BC Cricket Club at Brockton Oval in 1975. Umpire Maurice Dexter (centre). **John Denniston/*Province***

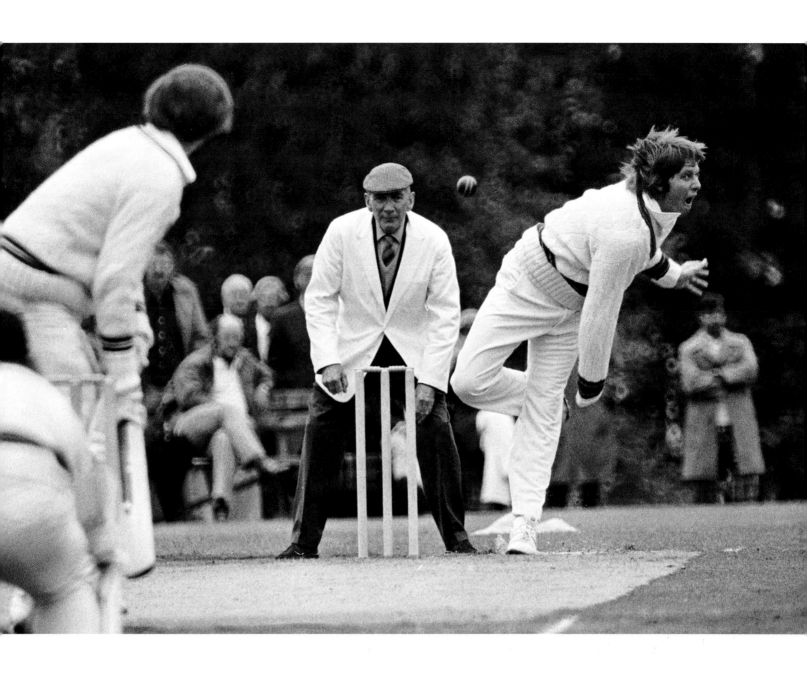

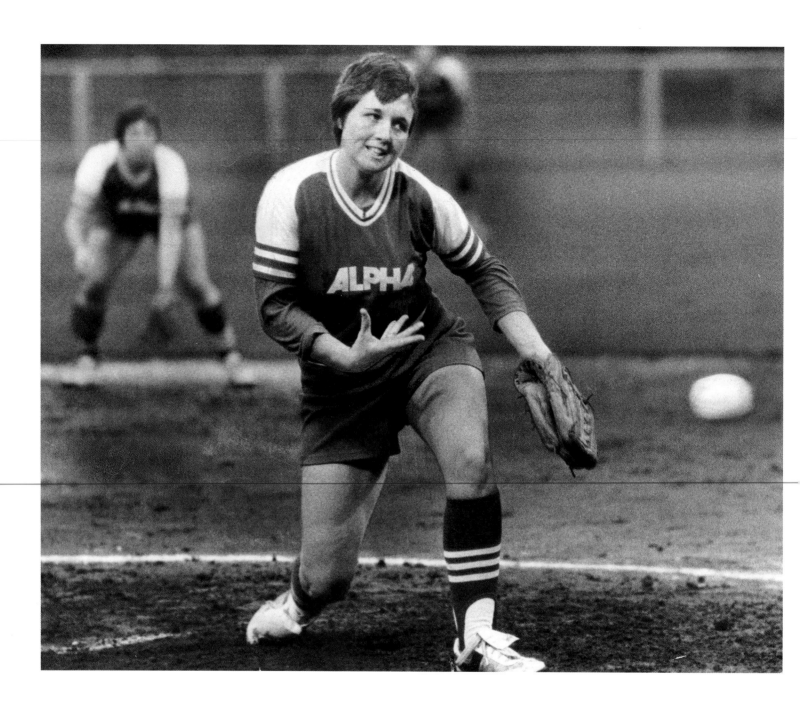

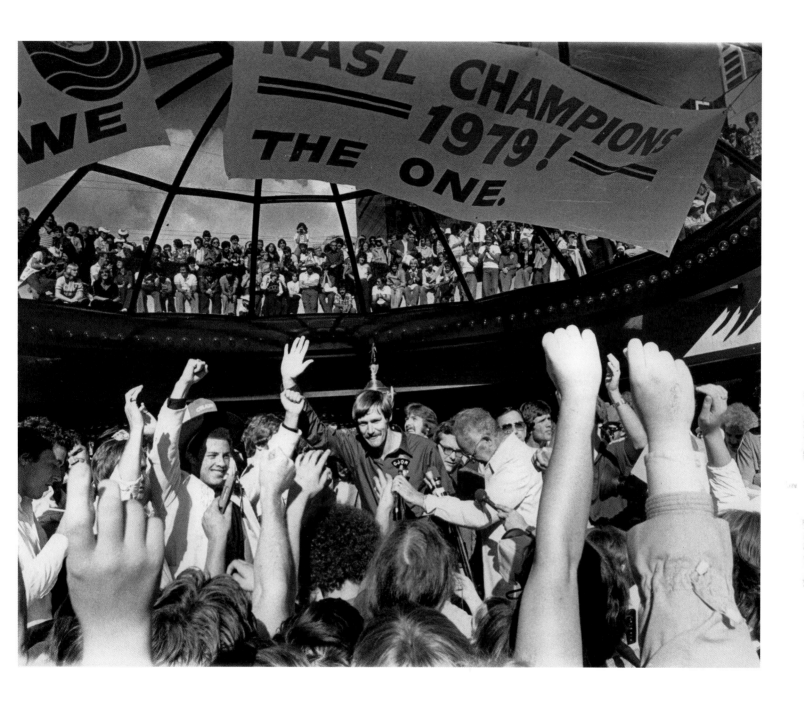

Facing: Victoria pitcher Rosemary Fuller helped Doc's Blues/Alpha Sports win nine BC and six Canadian softball titles, 1974–83, and silver at the 1978 world softball championships. *Vancouver Sun*

Above: Fans at Robson Square celebrated the Whitecaps' 1979 NASL championship win with player Carl Valentine (white suit) and head coach Tony Waiters (waving). Ralph Bower/*Vancouver Sun*

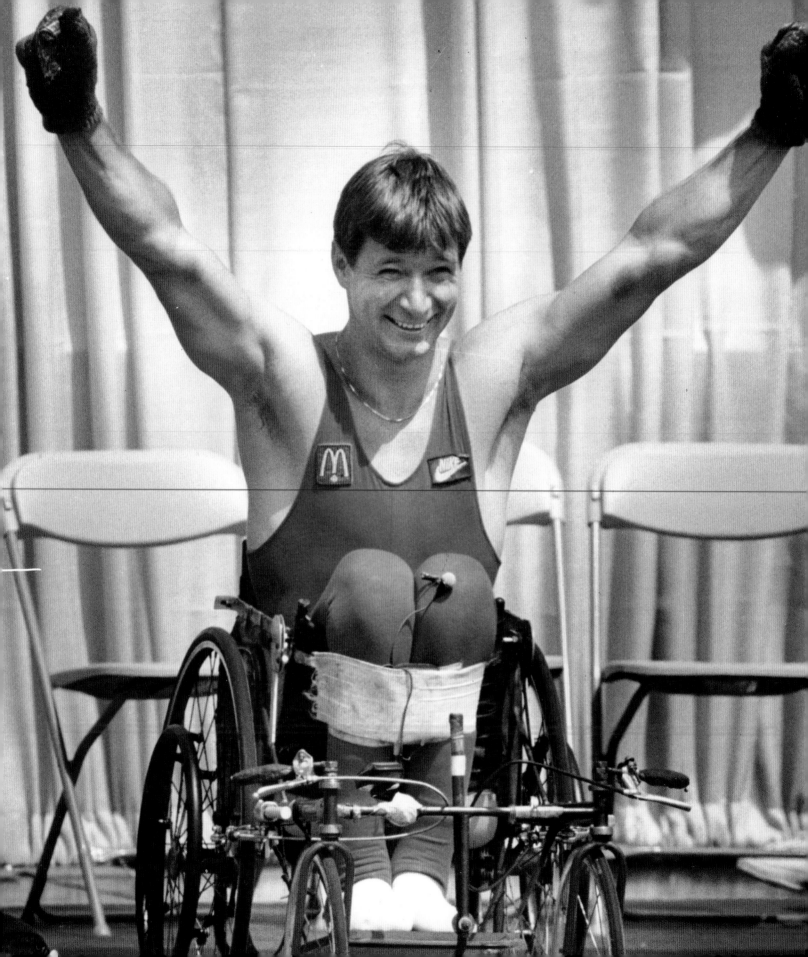

1980s

WHEN RICK HANSEN wheeled up to the podium at Vancouver's Oakridge Shopping Centre on May 22, 1987, it was the culmination not only of his Man in Motion World Tour to raise money for spinal cord research, but a historic moment in the evolution and development of wheelchair and disabled athletics in British Columbia.

Hansen, from Williams Lake, one of the world's finest wheelchair marathon and Paralympic athletes, was inspired by Coquitlam's Terry Fox, whose Marathon of Hope run across Canada for cancer research began in St. John's on April 12, 1980, and ended 143 days and 5,373 kilometres later in Thunder Bay when his cancer spread. Fox died June 28, 1981.

Nineteen-year-old Steve Fonyo from Vernon was also inspired by Terry Fox. Like Fox, Fonyo had lost a leg to cancer. He completed his 425-day 7,924-kilometre Journey for Lives run across Canada on May 29, 1985.

British Columbia has a long history of wheelchair sports. In 1950, Doug Mowat, Stan Stronge, Jim Mackie, and Walter Schmidt established the Dueck Powerglides wheelchair basketball team at Vancouver's Western Rehabilitation Centre. Rick Hansen and Terry Fox played with Abbotsford's Eugene Reimer, who dominated international wheelchair sports in the late 1960s and 1970s, on the successful Vancouver Cable Cars wheelchair basketball team. Marni Abbott-Peter, who met Rick Hansen in rehab after a skiing accident and wheeled in his Man in Motion World Tour, went on to win three gold medals and a bronze in Paralympic basketball.

Over the years, disabled sports organizations in British Columbia have provided funding, support, and training, enabling athletes with disabilities to succeed at the highest level of achievement. The Terry Fox Run, which began in 1981, is held annually in nine hundred Canadian communities and funds cancer research programs, and the Rick Hansen Foundation continues to provide education and fund spinal cord injury research and care.

Facing: Williams Lake's Rick Hansen, who wheeled over forty thousand kilometres through thirty-four countries over two years on his Man in Motion World Tour, completed his journey cheered by thousands of Vancouverites at Oakridge Shopping Centre on May 22, 1987. **Mark van Manen/***Vancouver Sun*

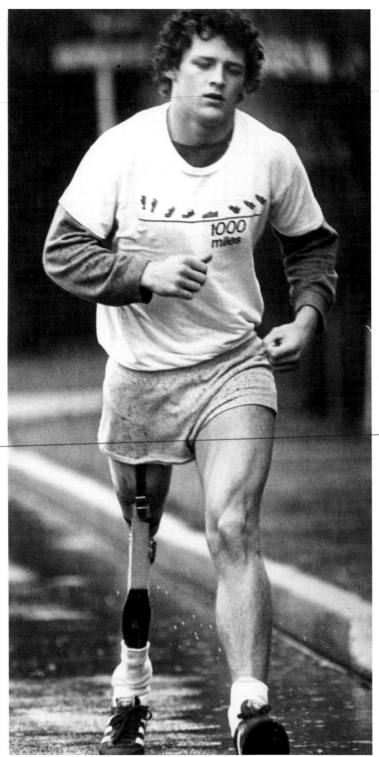

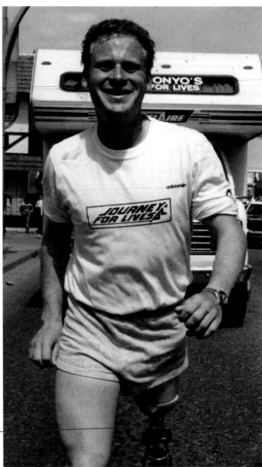

Above left: Terry Fox's 1980 Marathon of Hope ended after 143 days when his cancer spread. Since his 1981 death, annual Terry Fox Runs have raised over $750 million. **Colin Price/***Province*

Above right: Vernon's Steve Fonyo ran 7,924 kilometres across Canada and raised $14 million in his 1984–85 Journey for Lives run. **Gerry Kahrmann/***Province*

Facing: Vancouver's Alex Stieda (right) won the 1980 Gastown Grand Prix over Bernie Willock and in 1986 became the first North American to wear the yellow jersey in the Tour de France. **Peter Hulbert/***Province*

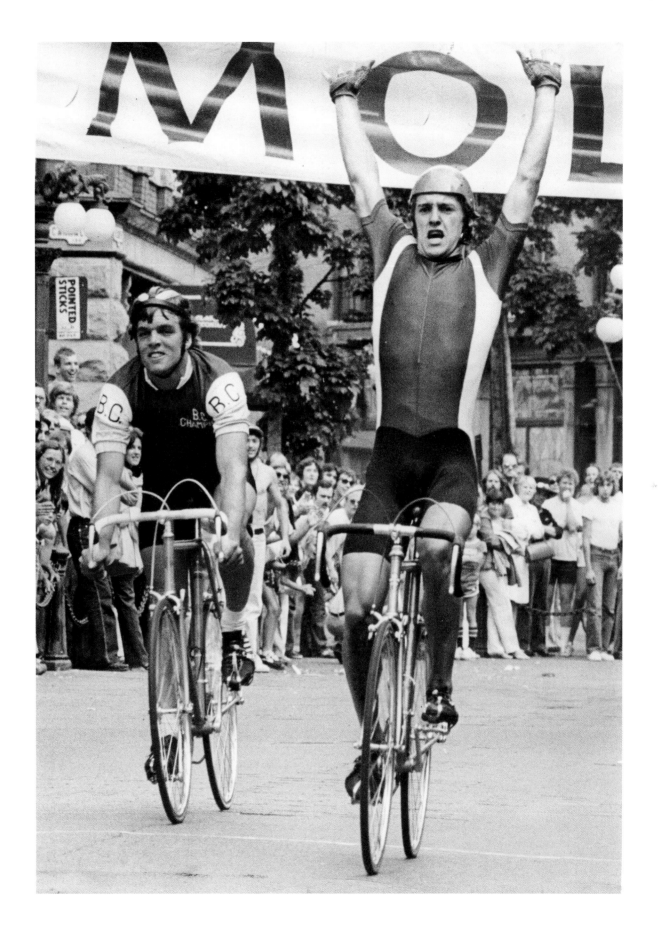

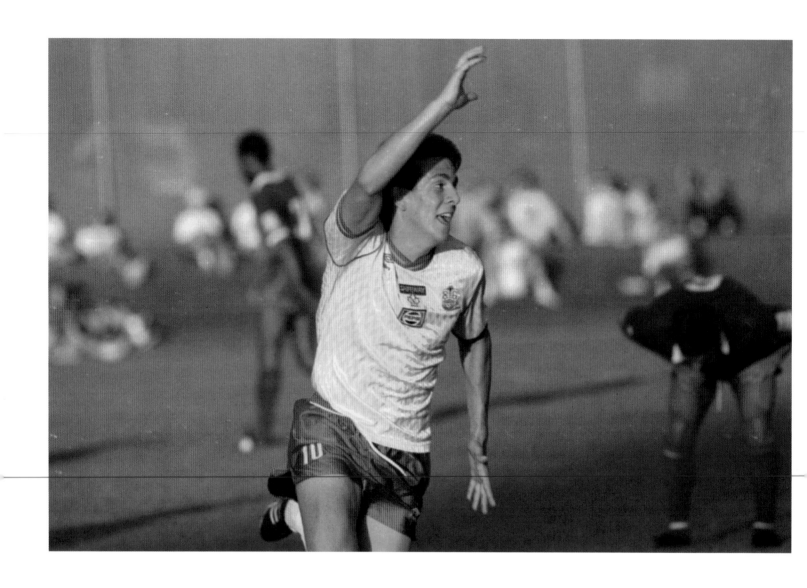

Above: Vancouver's Domenic Mobilio, pictured after scoring his third goal in a 1988 Vancouver 86ers game, holds the all-time club record of 170 goals (1987–2000). **Steve Bosch/*Vancouver Sun***

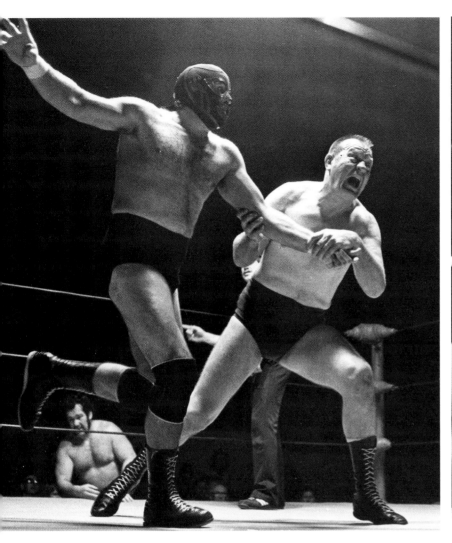

Above left: Vancouver wrestler Gene Kiniski (right) battling Moose Morowski at the PNE Gardens on December 26, 1980. **Wayne Leidenfrost/*Province***

Above right: Surrey's Velvet McIntyre (top) lost to Sherri Martel in the World Wrestling Federation women's title at the Pacific Coliseum on January 18, 1988. **Colin Price/*Province***

Facing: Fort Nelson's Chris Loseth, a record eight-time champion rider at Hastings Racecourse, won the 1984 Sovereign Award as Canada's Outstanding Jockey. **Ralph Bower/*Vancouver Sun***

Above: A bettor at Vancouver's Hastings Racecourse in 1981. The track has been in operation since 1892. **Steve Bosch/*Vancouver Sun***

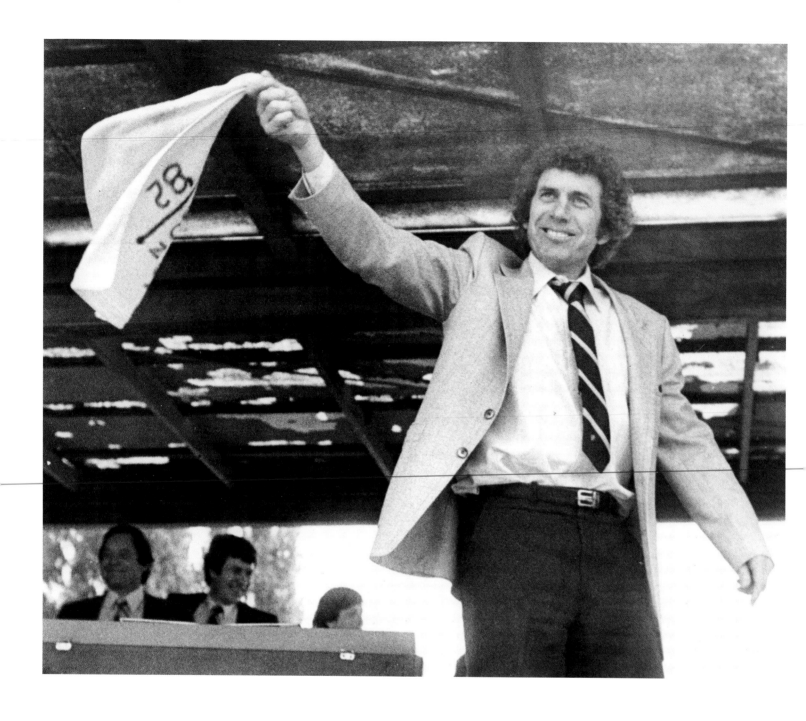

Above: Canucks coach Roger Neilson waved a white towel on a hockey stick in surrender to protest officiating in the 1982 Campbell Conference Final—and "Towel Power" was born. **Rick Loughran/*Province***

Facing top: Fans welcome the Canucks home on May 12, 1982, after they lost the first two games of the Stanley Cup Final against the New York Islanders. **Dan Scott/*Vancouver Sun***

Facing bottom: Fans mob Harold Snepsts of the Canucks at the airport on May 12, 1982. The Canucks went on to lose the Stanley Cup Final series 4–0. **Greg Osadchuk/*Province***

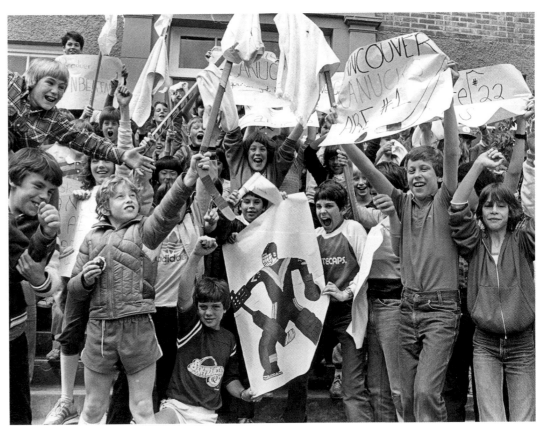

Above: In Carole Bishop's twenty-year volleyball career, 1962–82, she competed on nine Canadian championship teams 1967–73, 1979–80, and at the 1976 Olympics. **Deni Eagland/***Vancouver Sun*

Facing: SFU star guard Jay Triano (pictured in 1981) was drafted by the NBA in 1981, and coached SFU, 1988–95, Canada's national team, and in the NBA. **Ian Lindsay/***Vancouver Sun*

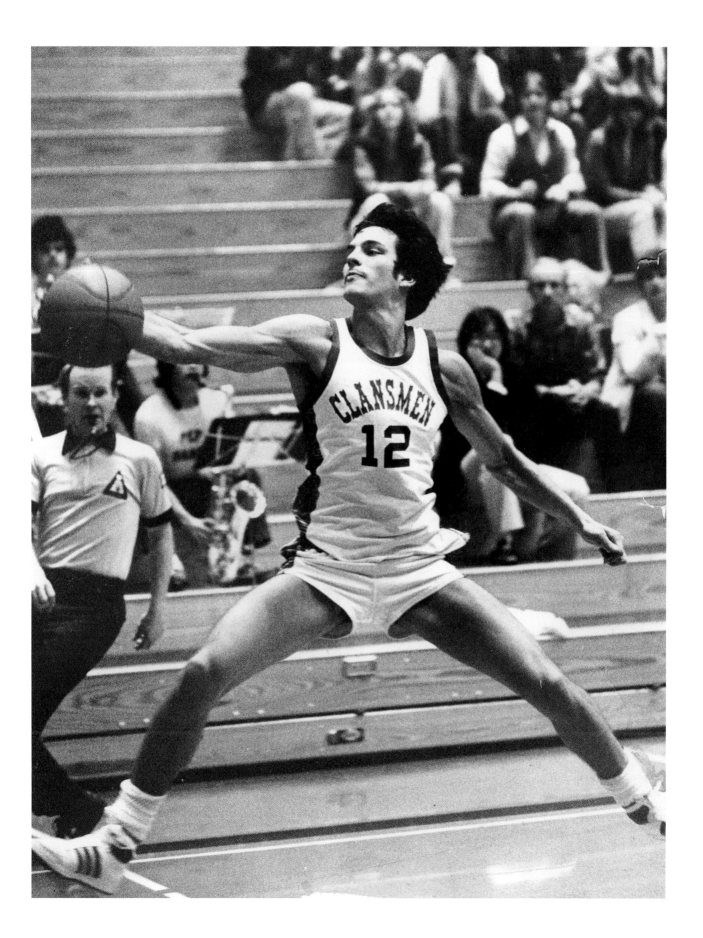

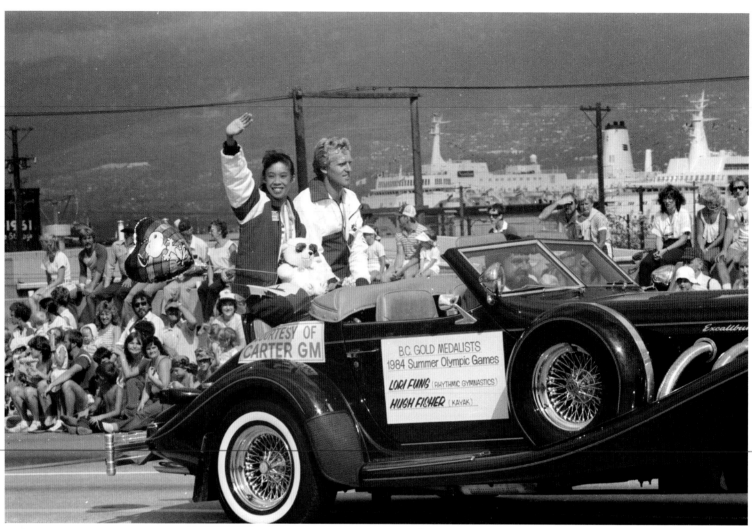

B.C. GOLD MEDALISTS
1984 Summer Olympic Games
LORI FUNG (RHYTHMIC GYMNASTICS)
HUGH FISHER (KAYAK)

COURTESY OF
CARTER GM

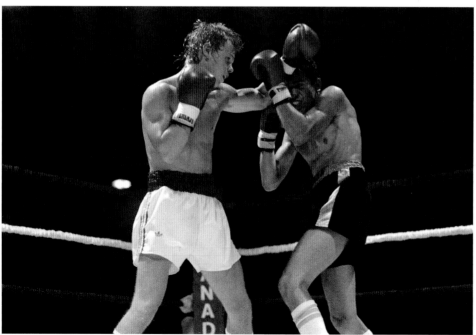

Facing top: Lori Fung, who won gold in rhythmic gymnastics at the 1984 Olympics, and Hugh Fisher, who won gold and bronze in kayaking, in the 1984 PNE parade. *Province*

Facing bottom: Boxer Dale Walters (left) fighting Arturo Guerrera at the North Vancouver Rec Centre in 1986. Port Alice's Walters won bantamweight bronze at the 1984 Olympics. **Rob Draper/***Vancouver Sun*

Above: The first BC Special Olympics was held on July 14, 1984, with five hundred athletes competing at UBC in floor hockey, swimming, and track and field. **John Denniston/***Province*

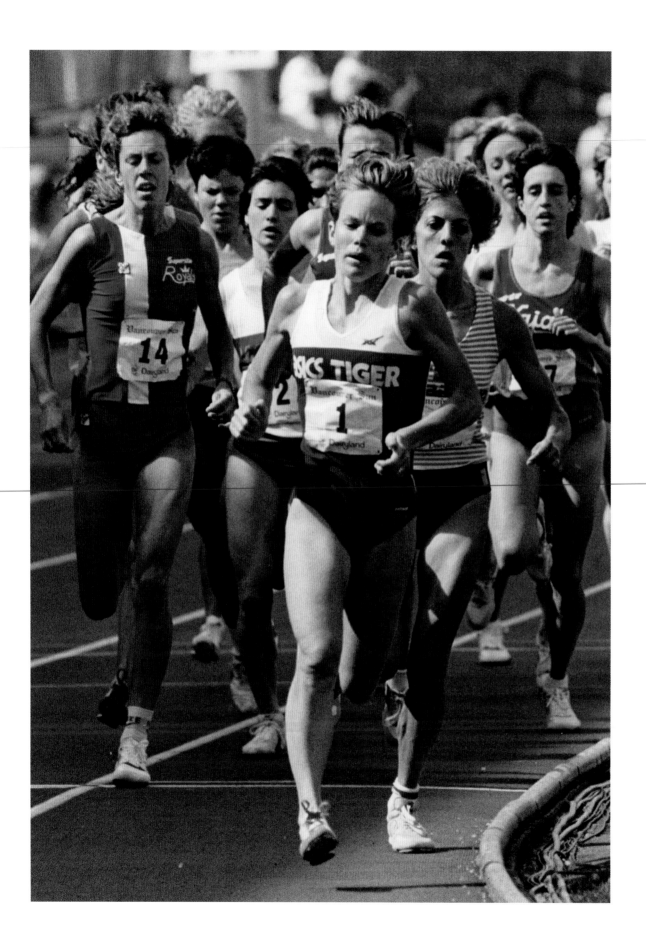

Facing: Vancouver's Lynn Kanuka, pictured (1) competing with Leah Pells (14) at the 1988 Harry Jerome International Track Classic, won bronze in the 3,000-metre race at the 1984 Olympics. **Colin Price/** ***Province***

Above: The first Vancouver Sun Run in 1985 (pictured), founded by Doug and Diane Clement and Jack Taunton, is now the third-largest timed 10-kilometre run in the world. **Peter Battistoni/***Vancouver Sun*

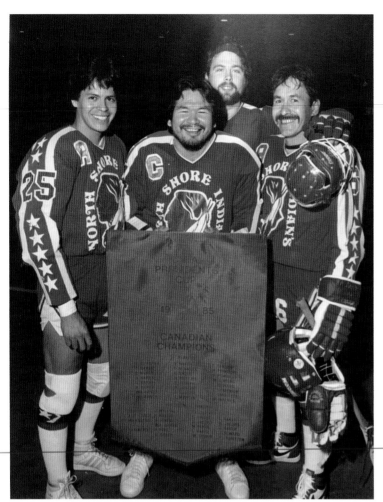

Above left: The North Shore Indians, from left, Barry Powless, Byron Joseph, Todd Semeniuk, and Lance Baker, won the 1985 Canadian Senior B lacrosse championship. **John Denniston/*Province***

Above right: Victoria's Helen Kelesi (left) and Jill Hetherington after defeating the Soviets in a 1987 Federation Cup match at Hollyburn Country Club. **Mark van Manen/*Vancouver Sun***

Left: Maple Ridge's Larry Walker played for the Montreal Expos, Colorado Rockies, and St. Louis Cardinals, 1989–2005, and won three MLB batting titles and seven Golden Gloves. He was named National League MVP in 1997. **Rick Loughran/*Province***

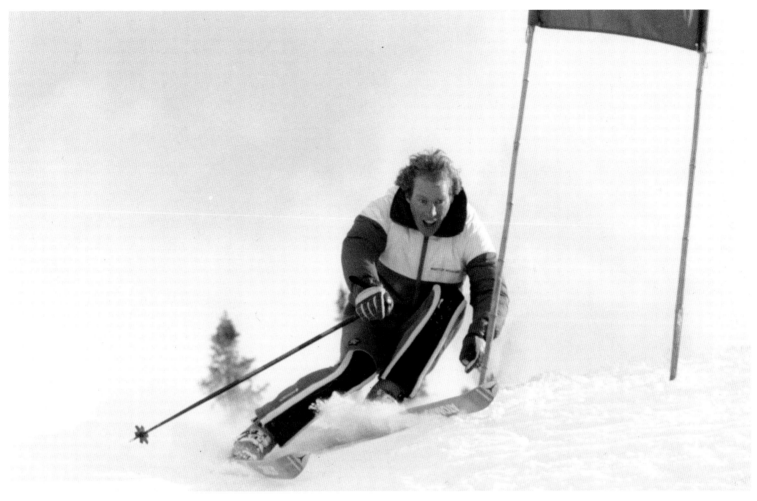

Above: Dave Murray earned three World Cup podium finishes in downhill skiing, was director of skiing at Whistler Blackcomb, and started the renowned Dave Murray Ski School. **Brian Kent/*Vancouver Sun***

Right: Victoria twins Gary (left) and Paul Gait, pictured in 1987 with the Esquimalt Legion, dominated in national, international, and professional lacrosse careers. **Peter Battistoni/*Vancouver Sun***

Above: The Canadian field hockey team won silver at the 1983 World Cup. From left, Suzanne Nicholson, Jack Taunton, Alison Palmer, Jody Blaxland, Diane Mahy, Heather Benson, Lynne Beecroft, Shelley Winter, Nancy Charlton, and Sharon Creelman.
Colin Price/*Province*

Facing: Trevor Linden (pictured in 1989) played for the Vancouver Canucks, 1988–98 and 2001–08, and was president of Canucks hockey operations, 2014–18.
Brian Kent/*Vancouver Sun*

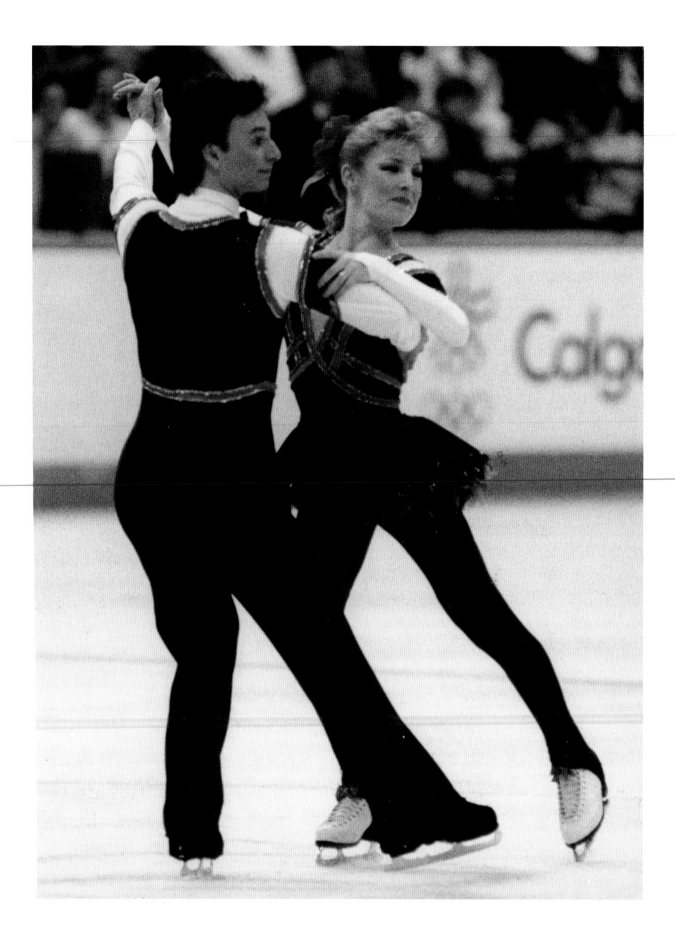

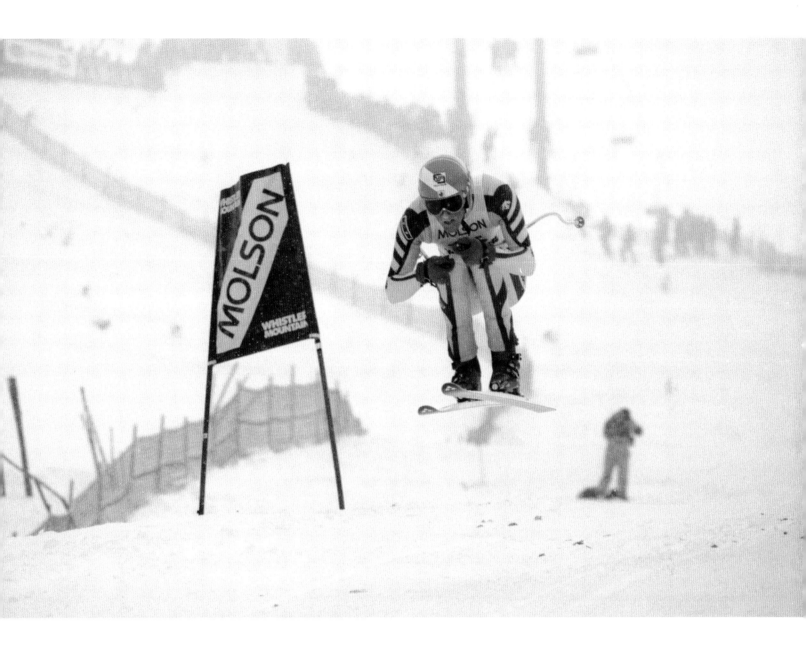

Facing: Rob McCall and Port Moody's Tracy Wilson, pictured winning bronze at the 1988 Olympics, were Canadian ice dance champions, 1982–88, and three-time world bronze medallists. **Bruce Stotesbury/ Postmedia**

Above: Rob Boyd, one of the "Crazy Canucks," winning the 1989 Molson Downhill at Whistler, becoming the first Canadian alpine skier to win an international-competition downhill race at home. **Brian Kent/***Vancouver Sun*

1990s

When Victoria's Angela Chalmers was named flag-bearer for the Canadian team at the opening ceremonies of the XV Commonwealth Games in Victoria's Centennial Stadium on August 18, 1994, the Indigenous track and field athlete quoted a saying in her ancestral Sioux language and offered the English translation, "everybody, play happily."

The crowd of 34,500 included Queen Elizabeth II, Prince Philip, and Prince Edward, as well as Governor General Ray Hnatyshyn and MP David Anderson. It was an event of firsts: the first Games in which disabled athletes competed alongside able-bodied athletes, and the first Games to extensively involve Indigenous people.

British Columbia medal-winners included: Chalmers, who won a gold in the 3,000-metre race, Chris Wilson won gold in lightweight wrestling, and Selwyn Tam won gold in flyweight wrestling. Richard Ikeda won a silver in horizontal bar, a bronze in pommel horse, and team gymnastics gold. Alison Sydor won a bronze in road cycling, and a silver in team time trial cycling. Charmaine Crooks won bronze in the 4x400-metre relay and silver in the 800-metre race, Glencora Maughan won bronze in 4x100-metre freestyle swimming, and Camille Martens won one gold and four silver medals in rhythmic gymnastics.

The 1994 Commonwealth Games also represented another first. In an effort to ensure timely coverage of the Games, *Vancouver Sun* and *Province* photographers Nick Didlick and Gerry Kahrmann employed the brand-new technology of digital photography. The NC2000, a camera jointly developed by the Associated Press and Kodak using a Nikon body, stored seventy-six images on a drive card, which were transmitted from Victoria via a modem to the newsrooms in Vancouver.

After the Commonwealth Games, Kahrmann and Didlick continued to shoot hockey and other sports with the digital cameras, until in the spring of 1995, the *Province* and the *Vancouver Sun* became the first newspapers in North America to switch to all-digital photography.

Facing: Flag-bearer Angela Chalmers, pictured at the opening of the 1994 Commonwealth Games, where she won gold in the 3,000-metres, won bronze in the 3,000-metres at the 1992 Olympics and gold in the 1,500-metres and 3,000-metres at the 1990 Commonwealth Games. **Ian Lindsay/***Vancouver Sun*

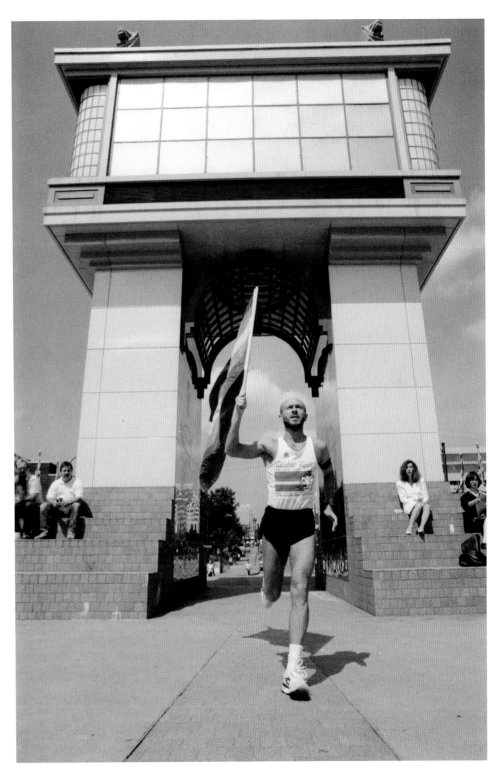

Facing: Maple Ridge's Greg Moore, pictured with his father Ric at the 1997 Molson Indy Vancouver, was a top Indy Lights and CART driver before his tragic death in 1999. **John Denniston/***Province*

Above: Brent Nicholson Earle, whose 1987 American Run for the End of AIDS was inspired by Terry Fox, ran from San Francisco to the opening of Gay Games III in Vancouver in 1990. **Brian Kent/** *Vancouver Sun*

Above: The BC taekwondo team practising for the 1991 Canadian championships in Vancouver. **Les Bazso/*Province***

Left: Alison Sydor, pictured at the 1993 Cheakamus Challenge in Whistler, won thirteen world championship medals and competed at four Olympics, winning silver in cross-country cycling at the 1996 Olympics. **Chris Relke/*Province***

Right: Diver Paige Gordon, pictured with sister Megan (right) in 1991, won silver at the 1991 Pan Am Games, and two silvers at the 1994 Commonwealth Games. Megan won five 10-metre silver medals. **Jon Murray/***Province*

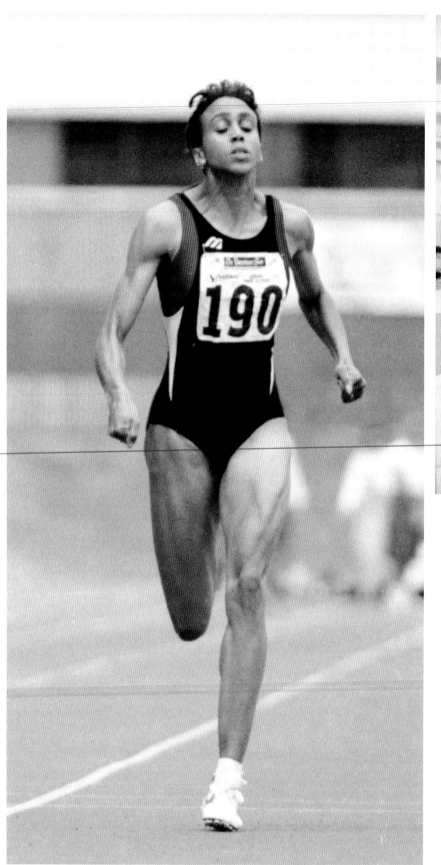

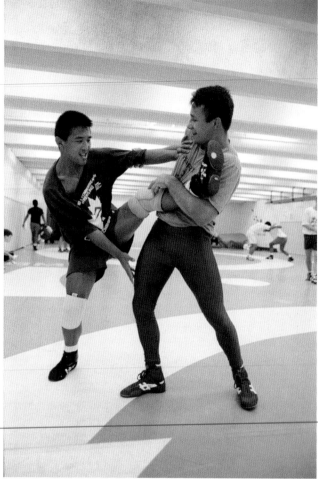

Left: Charmaine Crooks, the first Canadian female track athlete to compete at five Olympics, won Olympic silver, four Commonwealth medals, and three Pan Am medals, 1982–94. **Denise Howard/ Vancouver Sun**

Above: Wrestlers Selwyn Tam (left) and Chris Wilson, pictured training at SFU before the 1994 Commonwealth Games, each won gold in Victoria. **Rick Loughran/ Province**

Facing: Victoria's Steve Nash competing at the 1992 Provincial High School Boys Basketball Tournament in Vancouver. Nash went on to play in the NBA, 1996–2015, was league MVP in 2005 and 2006, and was inducted into the Naismith Memorial Basketball Hall of Fame in 2018. **Stuart Davis/Vancouver Sun**

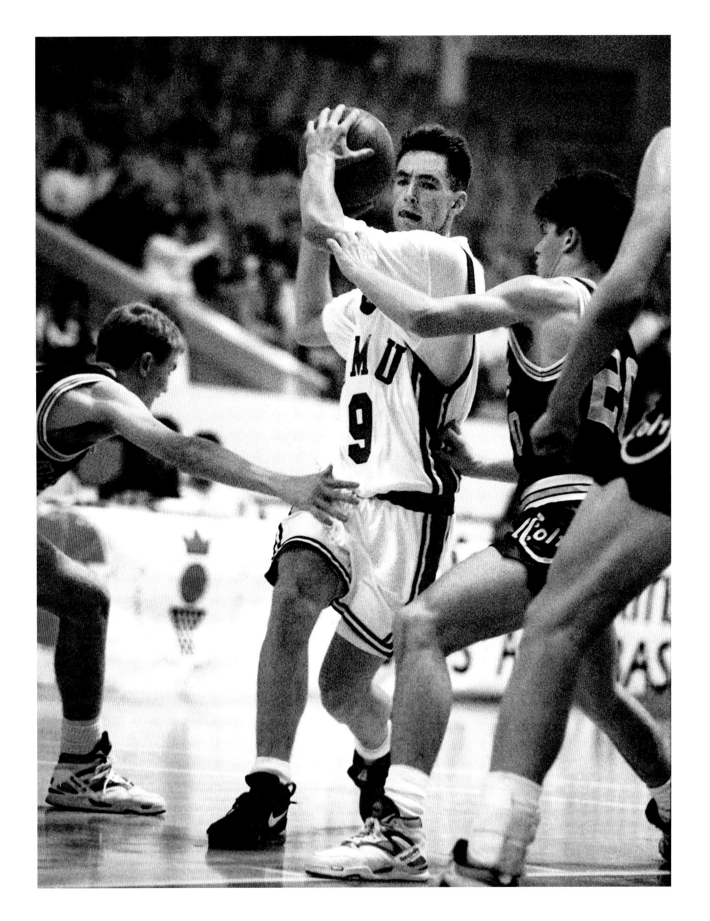

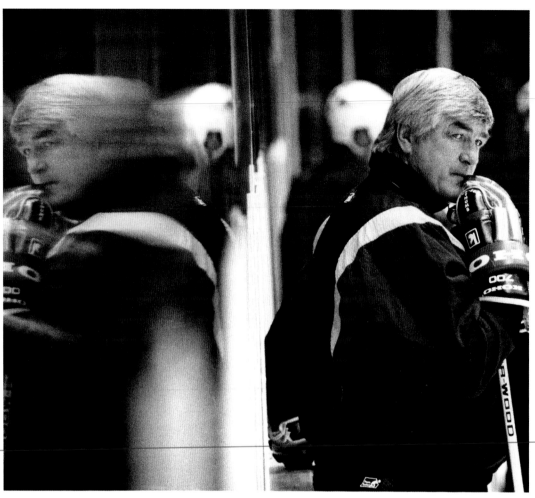

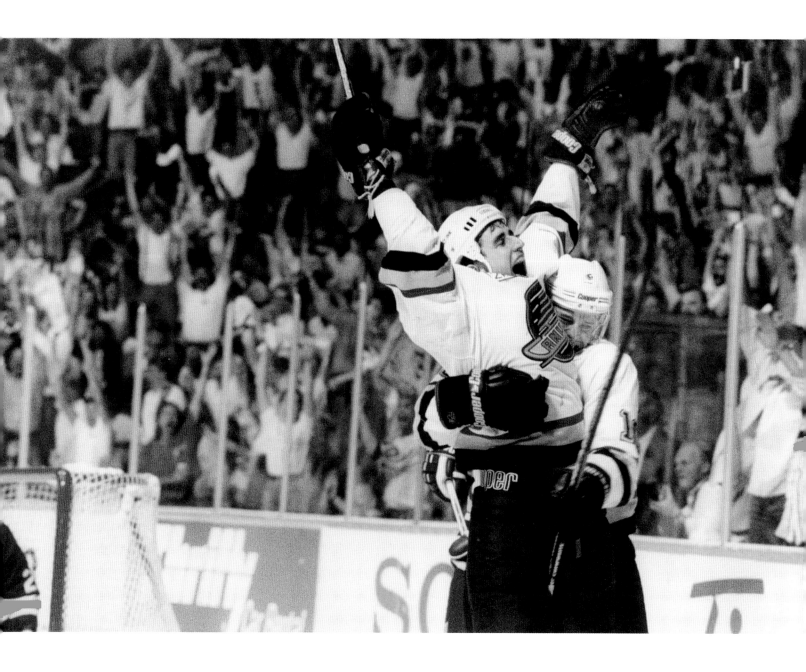

Facing top: Pat Quinn played nine NHL seasons, including 1970–72 with the Canucks, was the Canucks coach, 1987–97, and coached Canada's junior and Olympic teams. **Ian Smith/***Vancouver Sun*

Facing bottom: Pavel Bure, pictured with Dr. E.C. Rhodes at training camp in 1994, played for the Canucks, 1991–99, and was NHL scoring leader 1993–94. **Ralph Bower/***Vancouver Sun*

Above: Nelson's Greg Adams gets a hug from Pavel Bure after scoring the winning goal in the Western Conference Final to send the Canucks to the 1994 Stanley Cup Final. **Peter Battistoni/***Vancouver Sun*

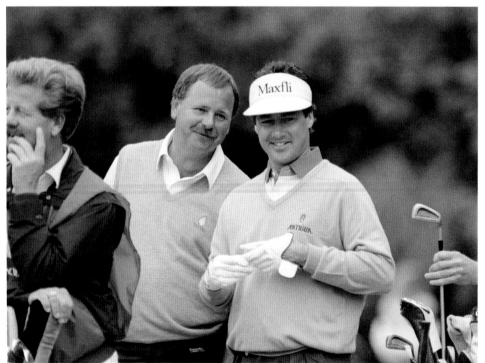

Above left: Lake Cowichan's Dawn Coe-Jones, pictured at the 1991 du Maurier Classic at the Vancouver Golf Club, won three LPGA events in a successful 25-year career. **Gerry Kahrmann/*Province***

Above right: Kitimat's Richard Zokol, pictured at the 1996 Carbite West Coast Classic at Swan-e-Set Bay Resort and Country Club in Pitt Meadows, had twenty top-ten finishes on the PGA tour. **Rick Loughran/*Province***

Left: Kelowna's Dave Barr (left) and Vancouver's Jim Nelford at the BC Open tournament at the Point Grey Golf and Country Club in 1991. **Bruce Stotesbury/*Province***

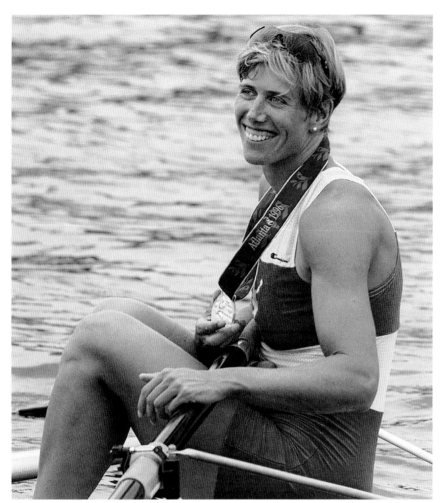

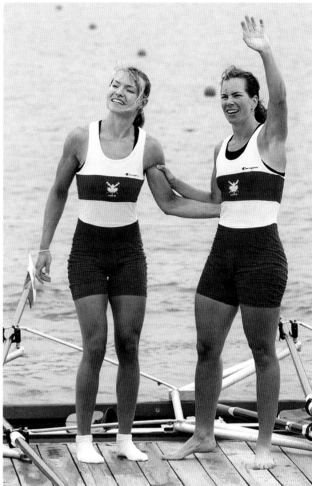

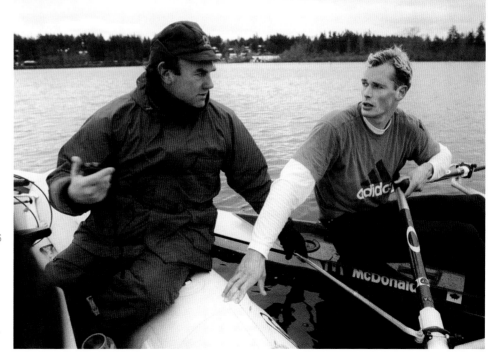

Above left: Silken Laumann, pictured after winning silver at the 1996 Olympics, won bronze at the 1992 Olympics, and gold at the 1987 and 1995 Pan Am Games. **Nick Didlick/***Vancouver Sun*

Above right: Kathleen Heddle (left) and Marnie McBean, pictured after their gold medal win at the 1996 Olympics, won two more golds and bronze at the 1992 and 1996 Olympics. **Nick Didlick/***Vancouver Sun*

Right: Derek Porter, pictured with coach Brian Richardson (left) at Elk Lake before the 1996 Olympics, where he won silver. Porter also won gold at the 1992 Olympics. **Peter Blashill/***Province*

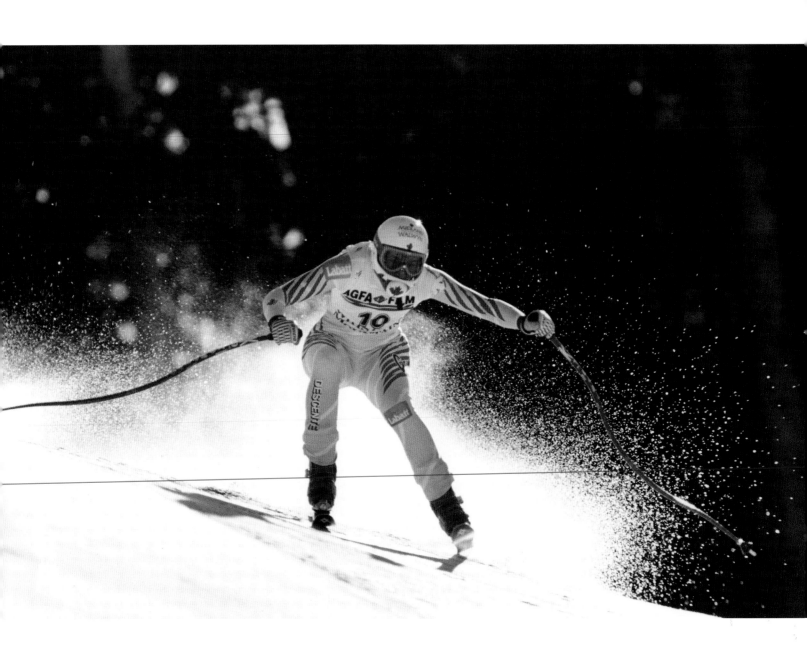

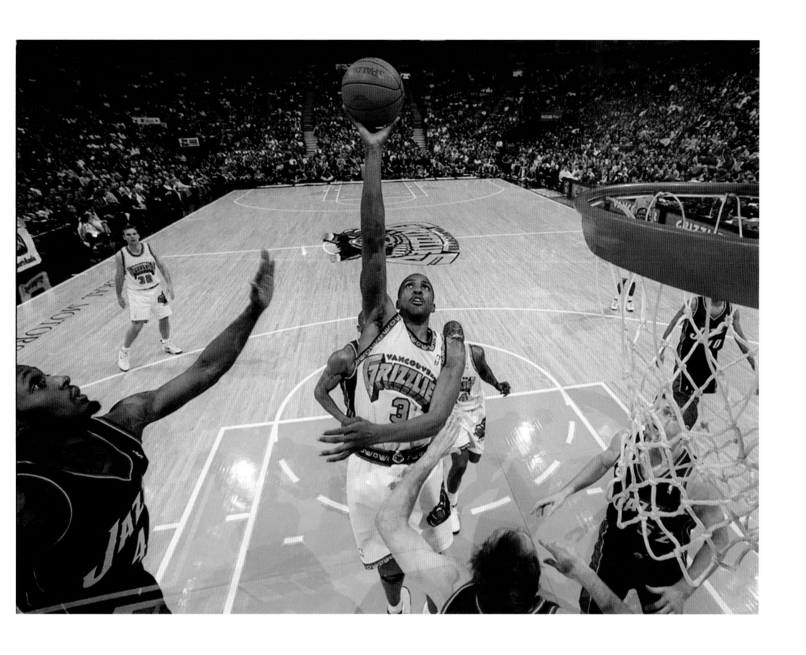

Facing: Trail's Kerrin Lee-Gartner, pictured in the final race of her career, won Canada's only gold medal in downhill skiing to date at the 1992 Olympics. **Nick Didlick/*Vancouver Sun***

Above: Shareef Abdur-Rahim (3) of the Vancouver Grizzlies at GM Place in 1999. The Grizzlies played in Vancouver, 1995–2001, before the team was moved to Memphis. **Gerry Kahrmann/*Province***

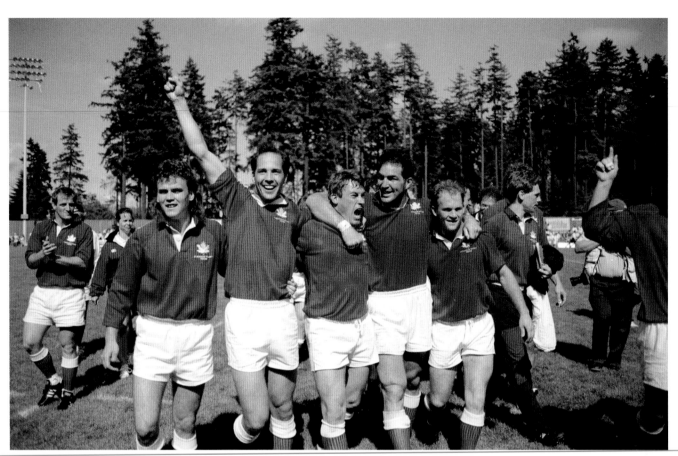
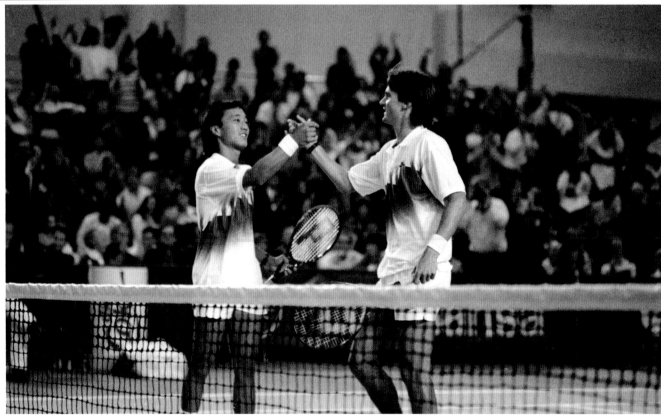

Facing top: Victoria's Gareth Rees, pictured (centre) after Canada's first-ever win over England in 1993, competed in four Rugby World Cups and was inducted into the World Rugby Hall of Fame. **Ian Smith/ *Vancouver Sun***

Facing bottom: Glenn Michibata (left) and Vancouver's Grant Connell, who won twenty-two career doubles titles, celebrate a 1990 Davis Cup win over Brazil. **John Denniston/*Province***

Above: The Vancouver VooDoo inline hockey team, which played in the Roller Hockey International league from 1993–96, won their division all four years. **Jon Murray/*Province***

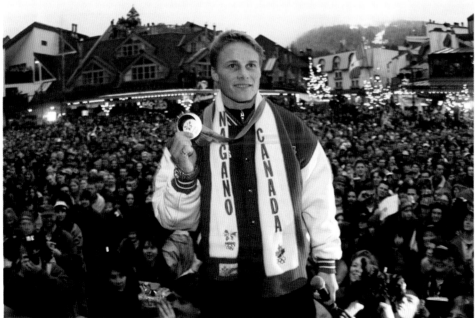

Above: Abbotsford's Ken Ikeda (left) competed at two Olympics, dad Mits was a top gymnastics coach, and brother Richard won three medals at the 1994 Commonwealth Games. **Ian Smith/** *Vancouver Sun*

Left: Ross Rebagliati, who won the first-ever Olympic gold medal in men's snowboard at the 1998 Olympics, at his Whistler homecoming party. **Gerry Kahrmann/** *Province*

Above: Nigerian-born Daniel Igali of Surrey sought refugee status in 1994, trained at SFU 1997–99 (pictured), and won gold in 69-kilogram freestyle wrestling at the 2000 Olympics. **Rob Kruyt/***Vancouver Sun*

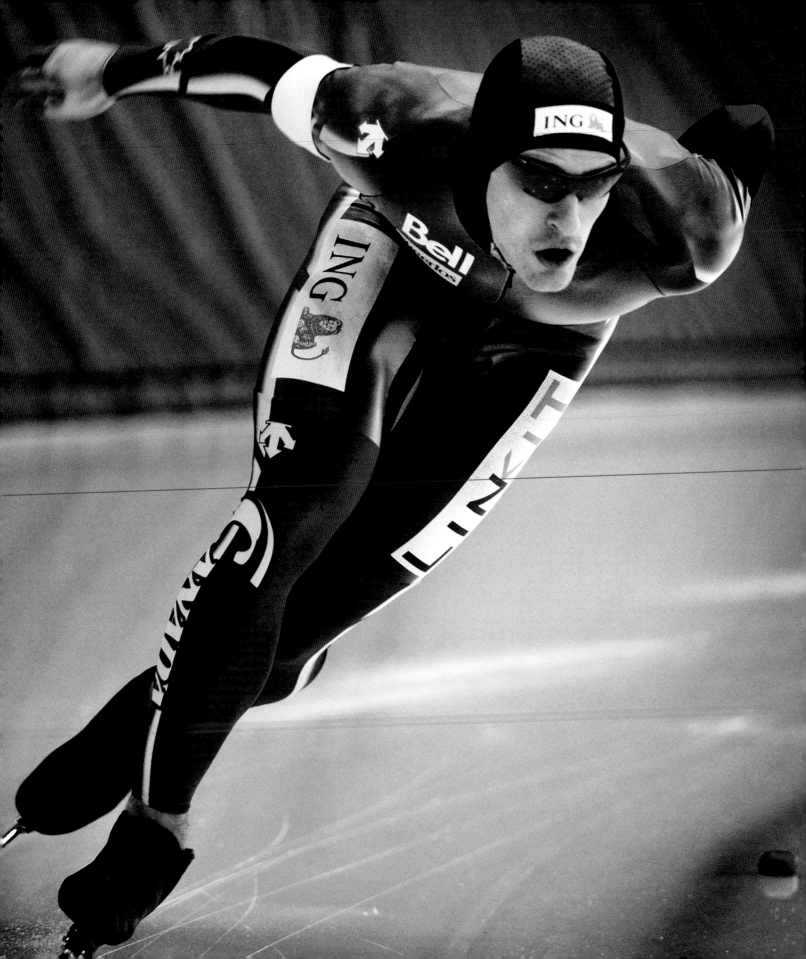

2000s

B Y THE FIRST decade of the twenty-first century, a culture of sports excellence in British Columbia had evolved, with grassroots sports organizations, athletic programs, training facilities, high-level coaching, and increased funding and opportunities, and BC athletes were regularly achieving top results in a wide range of sports. More athletes originated outside the Lower Mainland or Victoria, hailing instead from communities across the province: Olympic wrestler Carol Huynh from Hazelton, Montreal Canadiens goaltender Carey Price from Anahim Lake, and speed skater Denny Morrison from Fort St. John.

British Columbia has long produced fine hockey players, but few have been more outstanding than Burnaby's Joe Sakic and Cranbrook's Scott Niedermayer. "Burnaby Joe" played his entire twenty-year NHL career with the Quebec Nordiques/Colorado Avalanche franchise, with which he won two Stanley Cups. He also won a gold medal and was MVP at the 2002 Olympics in Salt Lake City. Niedermayer played eighteen seasons in the NHL, won four Stanley Cup championships, three with the New Jersey Devils and one with the Anaheim Ducks, and also won Olympic gold: with Sakic in 2002 and on home ice in Vancouver in 2010.

Kelley Law's rink won the 2000 curling world championships and the bronze medal at the 2002 Olympics. In 2003, Shae-Lynn Bourne and Vancouver's Victor Kraatz became the first North American ice dancers to win a World Championship, and figure skater Emanuel Sandhu was the 2004 Grand Prix Final champion.

In 2005, Maple Ridge's Larry Walker retired after a remarkable seventeen-year career in Major League Baseball during which he won three batting titles and seven Gold Gloves. Often cited as one of the greatest Montreal Expos of all time, Walker won the National League MVP award in 1997 playing for the Colorado Rockies.

Victoria native Steve Nash overcame incredible odds, and obstacles, to become one of the finest athletes BC has produced. Undersized, and recruited by only one U.S. college—tiny Santa Clara University—to play basketball, Nash not only made it to the NBA, he won the Most Valuable Player award twice, in 2005 and 2006. Nash opened his speech at his induction ceremony into the Basketball Hall of Fame in 2018 with, "I was never, ever, supposed to be here."

Facing: Fort St. John speed skater Denny Morrison, pictured competing at Richmond Olympic Oval in 2008, won Olympic gold (2010), silver (2006, 2014), and bronze (2014). **Ian Lindsay/***Vancouver Sun*

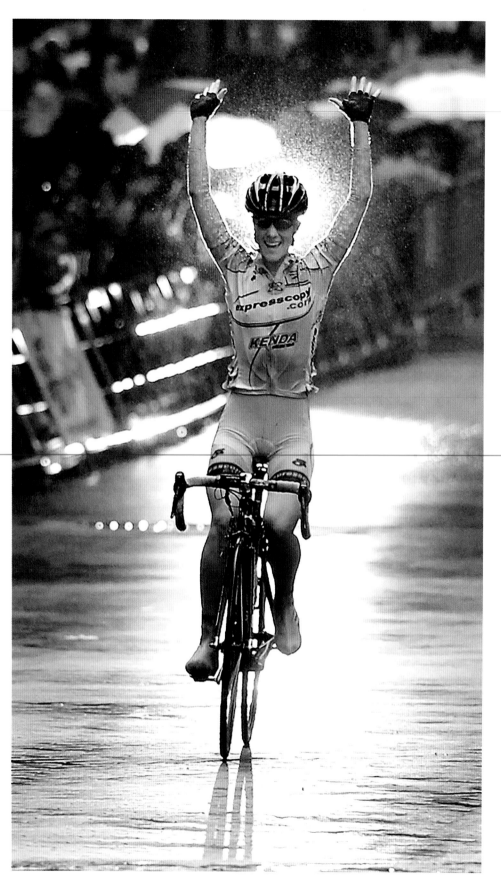

Left: Victoria's Erinne Willock, pictured winning the 2007 Tour de Gastown, won silver at the 2006 Pan American Road and Track Championships, and competed at the 2008 Olympics. **Ric Ernst/***Province*

Facing top: Victoria's Ryan Cochrane, pictured at the 2008 Mel Zajac Jr. International Swim Meet at UBC, won bronze at the 2008 Olympics, silver at the 2012 Olympics, and eight world championship medals. **Jason Payne/***Province*

Facing bottom: Victoria's Ryder Hesjedal, a former mountain biker pictured at the 2001 World Cup at Grouse Mountain, was the first Canadian road cyclist to win the Giro d'Italia, in 2012. **Peter Battistoni/** *Vancouver Sun*

Facing: Shae-Lynn Bourne and Vancouver's Victor Kraatz, pictured at the 2001 World Championships in Vancouver, won four bronze and one silver medal at the World Championships before becoming, in 2003, the first North American ice dancers to win a World Championship. **Arlen Redekop/ *Province***

Above: Emanuel Sandhu, pictured at Burnaby 8 Rinks in 2006, won silver at the 2004 Four Continents Figure Skating Championships, and gold at the 2004 Grand Prix Final. **Ian Lindsay/ *Vancouver Sun***

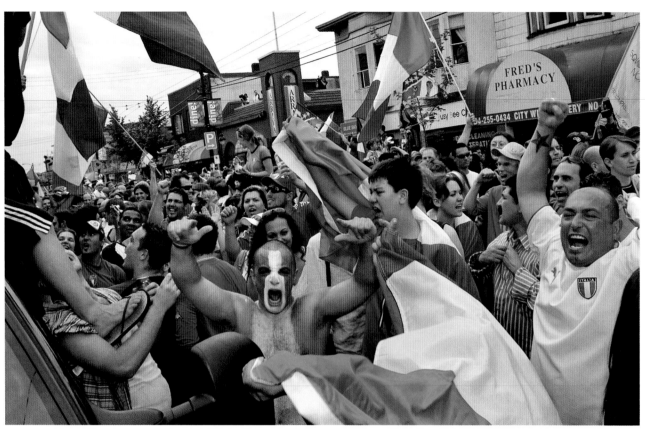

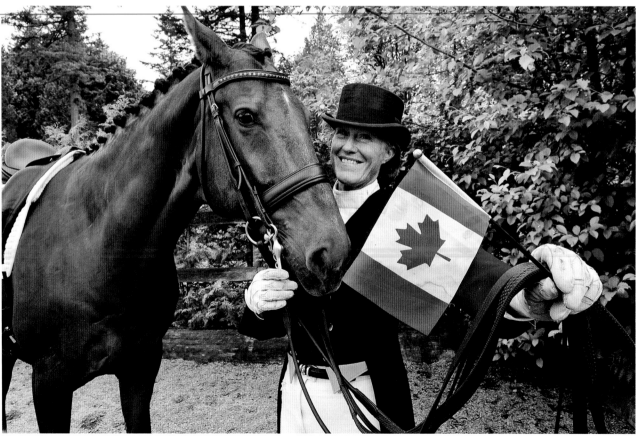

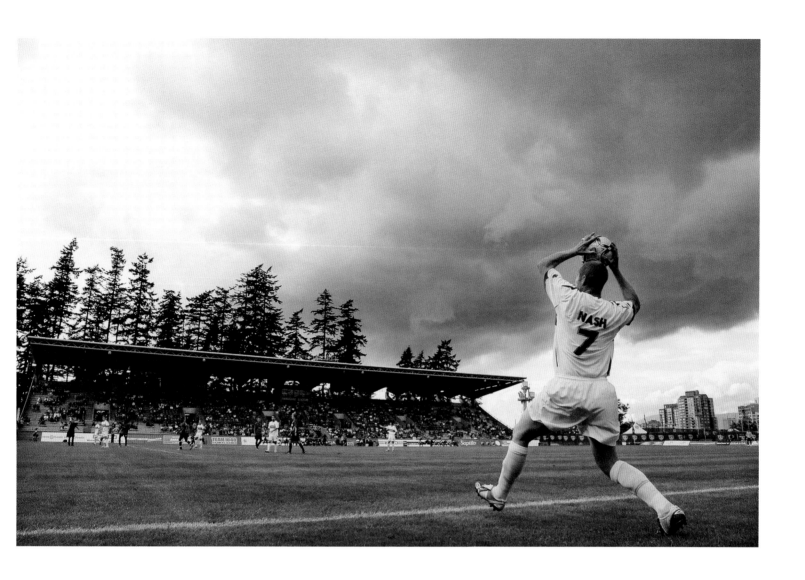

Facing top: Soccer fans on Vancouver's Commercial Drive celebrating Italy's 2006 World Cup win over France. **Peter Battistoni/***Vancouver Sun*

Facing bottom: Langley's Leslie Reid, pictured with horse Orion in 2008, competed in dressage at the 2004 and 2008 Olympics, and won three medals at the Pan Am Games. **Bill Keay/***Vancouver Sun*

Above: Victoria's Martin Nash, pictured in 2008, played with the Vancouver 86ers, 1995–96, 1999, the Whitecaps, 2004–10, and on Canada's national team, 1997–2010. **Ric Ernst/***Province*

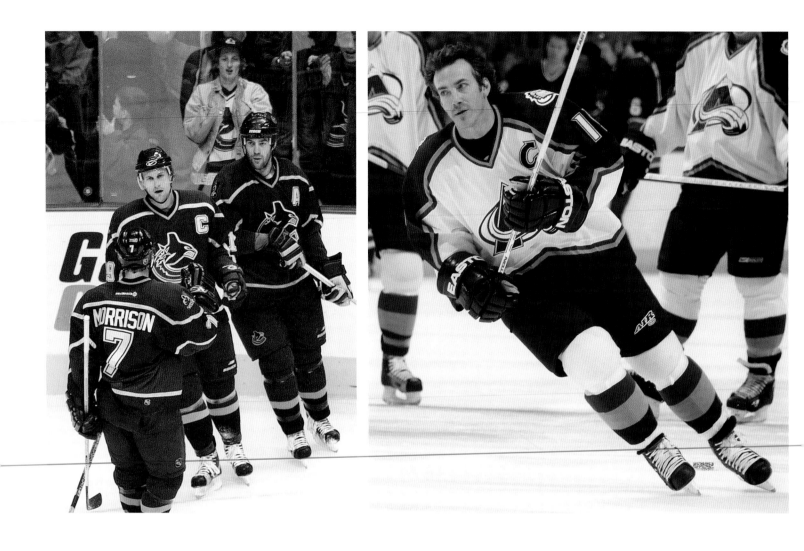

Above left: The Vancouver Canucks' top scoring line, 2002–06, nicknamed the West Coast Express, from left, Brendan Morrison, Markus Naslund, and Todd Bertuzzi. **Steve Bosch/*Vancouver Sun***

Above right: Burnaby's Joe Sakic played for the Quebec Nordiques/Colorado Avalanche franchise, 1988–2009, won Stanley Cups in 1996 and 2001, and won gold and was MVP at the 2002 Olympics. **Ric Ernst/*Province***

Facing: Canada's Meghan Agosta (centre) scored in the gold medal game in a losing effort against the U.S. at the 2009 Hockey Canada Cup at GM Place. **Ric Ernst/*Province***

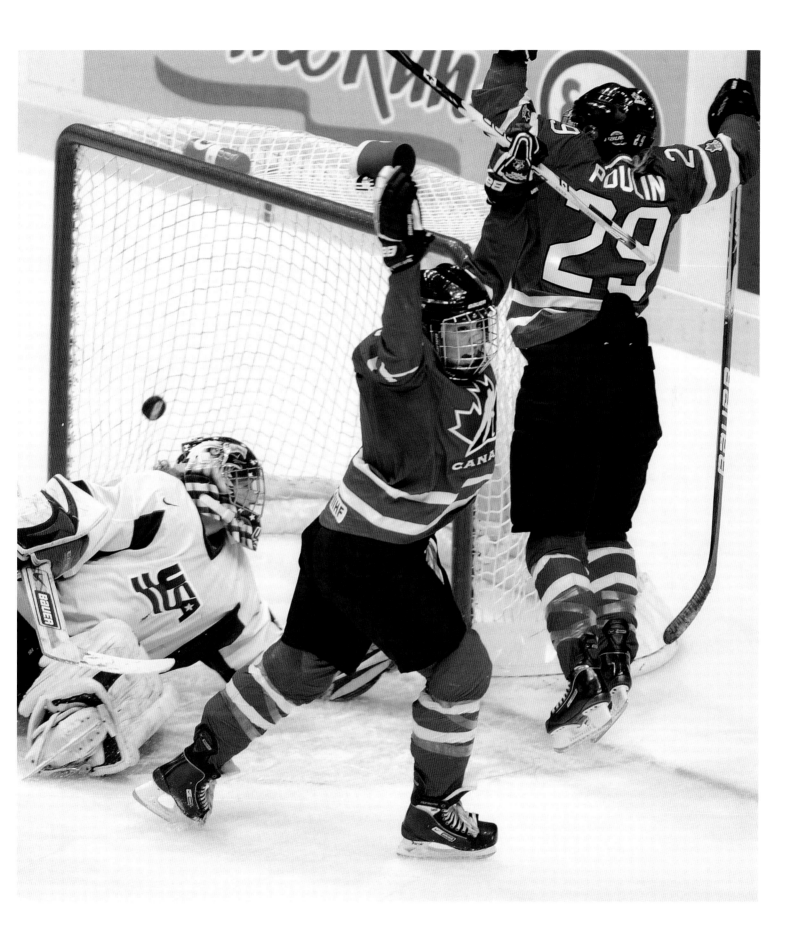

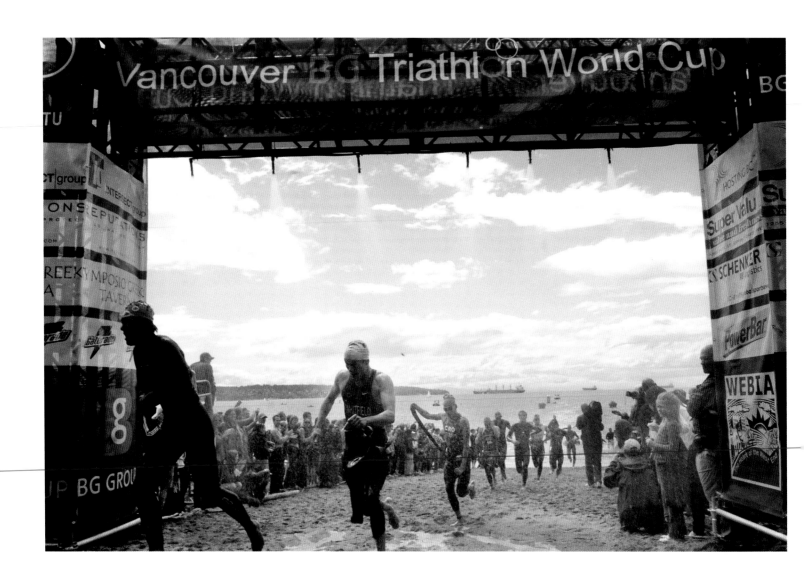

Facing: Victoria triathlete Simon Whitfield, pictured at the 2007 Vancouver BG Triathlon World Championships, won gold at the 2000 Olympics, and silver at the 2008 Olympics. **Les Bazso/***Province*

Above: Chilliwack's David Ford, pictured on the Chilliwack River in 2000, won kayaking silver at the 2003 world championships, and competed at five Olympics 1992–2008. **Peter Battistoni/***Vancouver Sun*

Above left: Vancouver's Tami Bradley, pictured winning bronze in moguls at the 2001 Freestyle World Championships at Blackcomb, competed at the 1998 and 2002 Olympics. **Ric Ernst/***Province*

Above right: Ashleigh McIvor, pictured with Cedardale students in 2009, won the 2009 World Championships, and the first gold in women's ski cross at the 2010 Olympics. **Ian Lindsay/***Vancouver Sun*

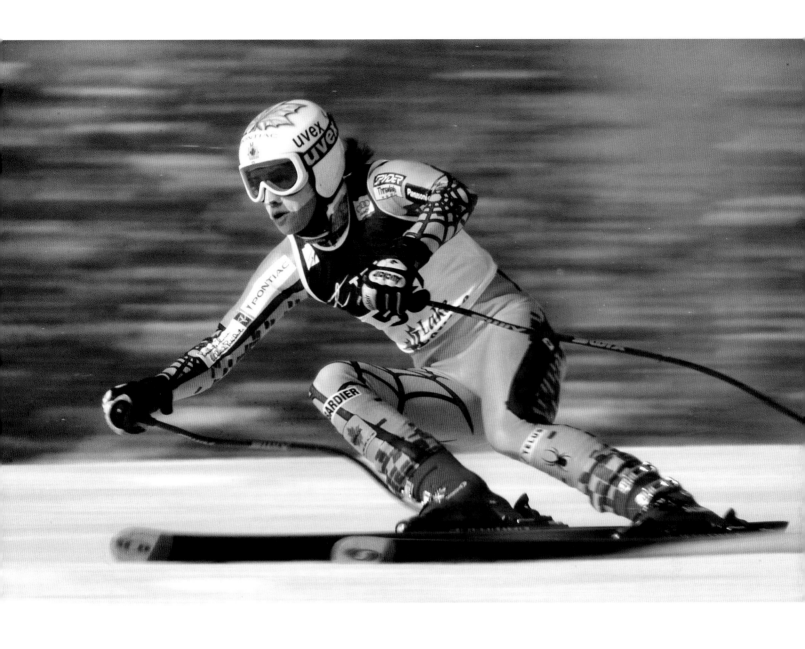

Above: Georgia Simmerling, pictured at the 2008 World Cup, is the only Canadian to compete in three sports (skiing, ski cross, cycling) at three Olympics. **Jenelle Schneider/***Vancouver Sun*

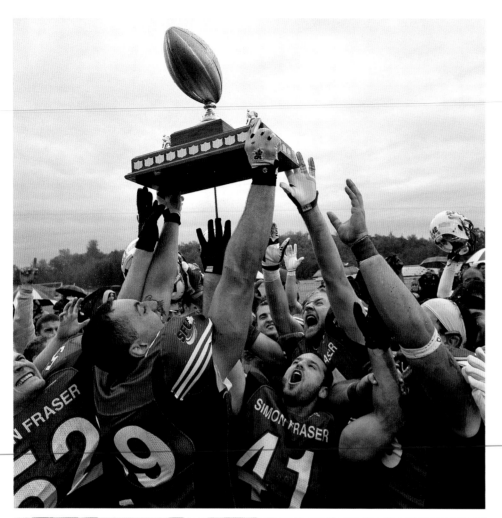

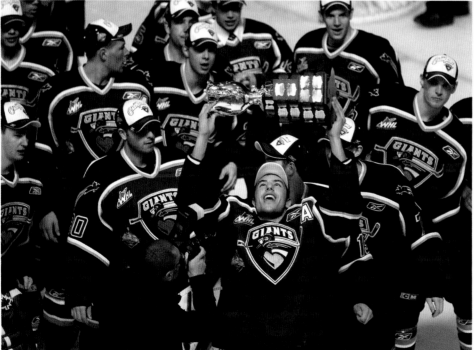

Top: The Shrum Bowl was an annual football game, 1967–2010, between the UBC Thunderbirds and the SFU Clan. Pictured, SFU after their 2009 win. **Ian Smith/ *Vancouver Sun***

Bottom: Vancouver's Milan Lucic, pictured with the Memorial Cup the Vancouver Giants won in 2007, and named tournament MVP, went on to win the 2011 Stanley Cup with the Boston Bruins. **Ric Ernst/ *Province***

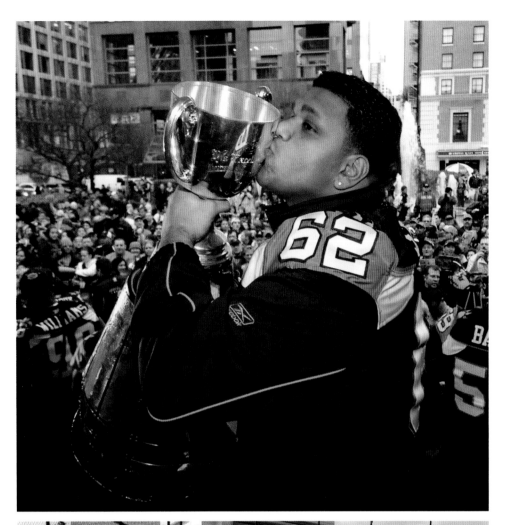

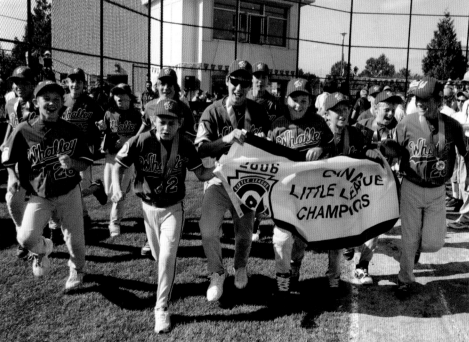

Top: Richmond's Bobby Singh, the only player in football history to win an XFL championship, a Super Bowl, and a Grey Cup, after the BC Lions' 2006 Grey Cup victory. **Ian Lindsay/***Vancouver Sun*

Bottom: Many BC teams have won the Canadian Little League Championship (pictured is the 2006 Whalley team) and represented their country at the Little League World Series in Williamsport, Pennsylvania. **Richard Lam/***Vancouver Sun*

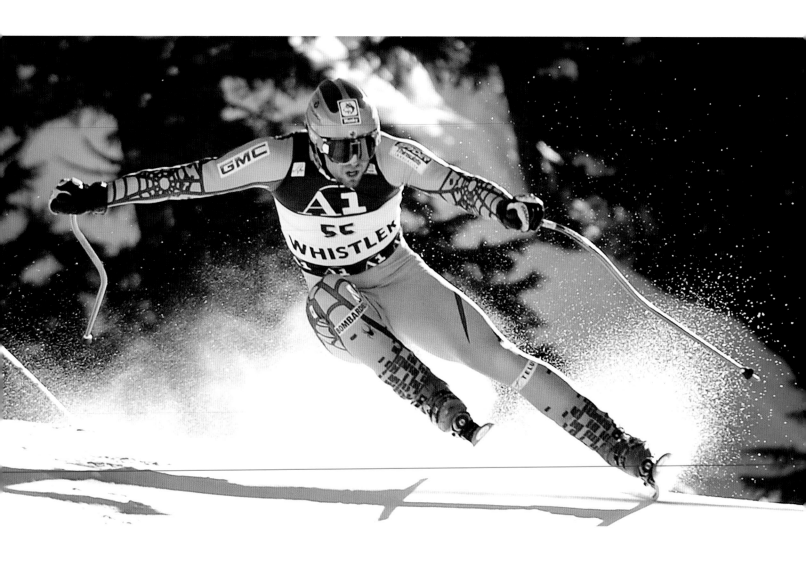

Above: Alpine skier Manuel Osborne-Paradis, pictured in 2008, had eleven podium finishes, 2007–15, competed at four Olympics, and won bronze at the 2017 World Championships. **Mark van Manen/ *Vancouver Sun***

Facing left: Burnaby's Marni Abbott-Peter won three gold medals and a bronze in women's wheelchair basketball at four Paralympics (1992, 1996, 2000, 2004). **Ward Perrin/*Vancouver Sun***

Facing right: Whalley Chief Adam Loewen (left) and UBC Thunderbird Jeff Francis in 2002, the year they were selected fourth and ninth overall, respectively, in the Major League Baseball draft. **Richard Lam/UBC**

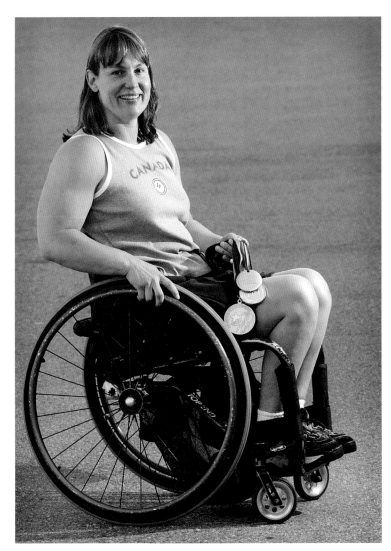

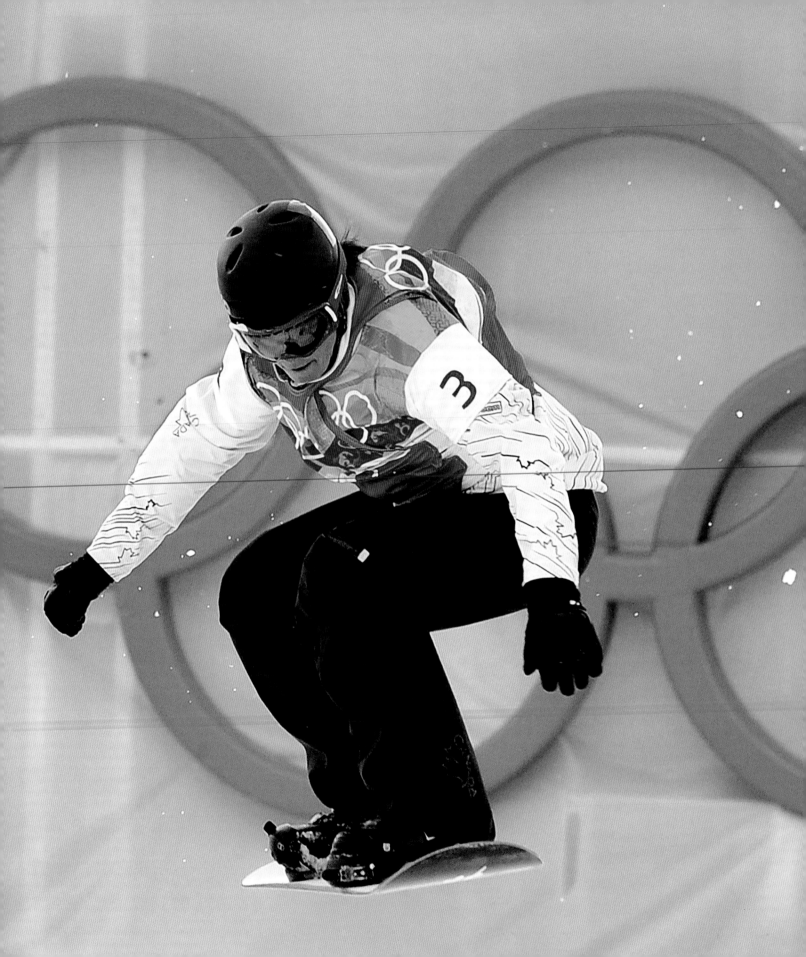

2010s

For the 2010 Winter Olympics torch relay, 12,000 torchbearers, using one hundred different methods, transported the Olympic torch through 1,036 communities across Canada for 106 days leading up to the opening ceremonies on February 12. The five final torchbearers were Rick Hansen, Catriona Le May Doan, Steve Nash, Nancy Greene Raine, and Wayne Gretzky. Two out of three Canadians watched at least part of the opening ceremonies, making it the most watched television event in Canadian history, with an estimated worldwide audience of over three billion.

Canada won a national record of fourteen gold medals during the 2010 Games, and a total of twenty-six medals. North Vancouver's Maëlle Ricker became the first Canadian woman to win an Olympic gold medal on home soil—or rather home *snow*—in the snowboard cross event, and Lauren Woolstencroft, also from North Vancouver, won five gold medals for Paralympic skiing. In a storybook ending, Sidney Crosby scored the winning goal in overtime during the men's gold medal hockey game against the U.S., sending thousands of revellers on Granville Street into a frenzy of high-fiving and flag-waving.

Over 3.5 million pairs of red mittens were sold for the 2010 Olympics, and sales of Olympics clothing were five times higher than for other Games. Almost a decade later, at any winter sports event in British Columbia, it is common to see folks wearing 2010 gear, including the red mittens.

The past century has seen our province evolve from an athletic backwater into a recognized centre of sports excellence. A remarkable 38 percent of Team Canada athletes and coaches for the 2018 Winter Olympics in PyeongChang came from or trained in British Columbia.

From the growth of community and recreational sports around the province, to the successful hosting of large-scale sports events, and the impressive development of world-class athletes, British Columbia's vibrant and compelling history of sports is something to celebrate with pride.

Facing: North Vancouver's Maëlle Ricker won gold in snowboard cross at the 2010 Olympics in Vancouver, becoming the first Canadian woman to win an Olympic gold medal on home soil, bronze at the 2012 Winter X Games, and gold at the 2013 FIS World Championships. Jenelle Schneider/PNG

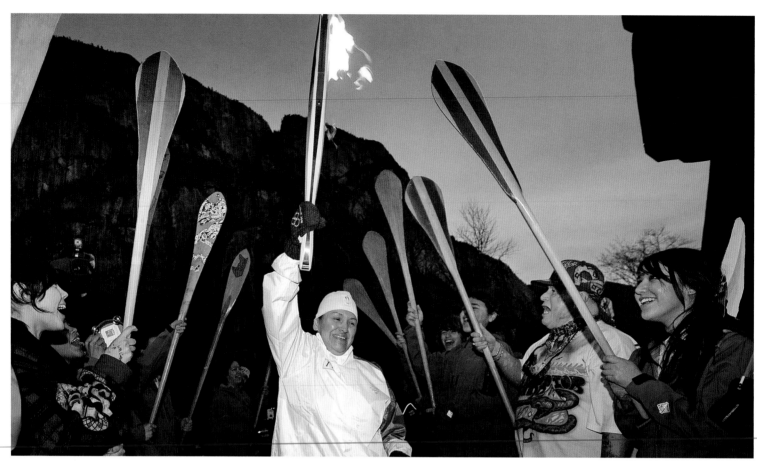

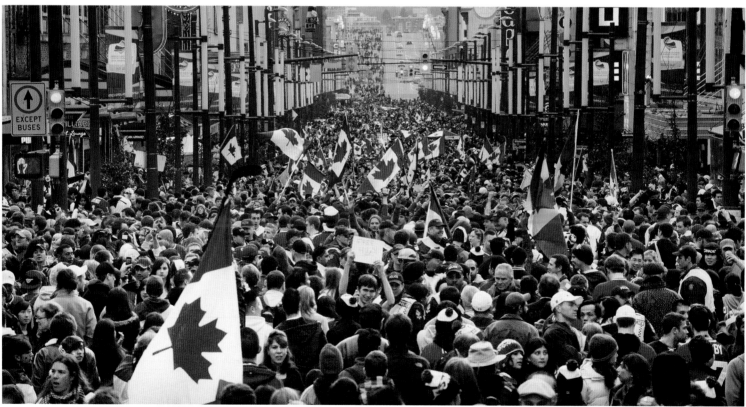

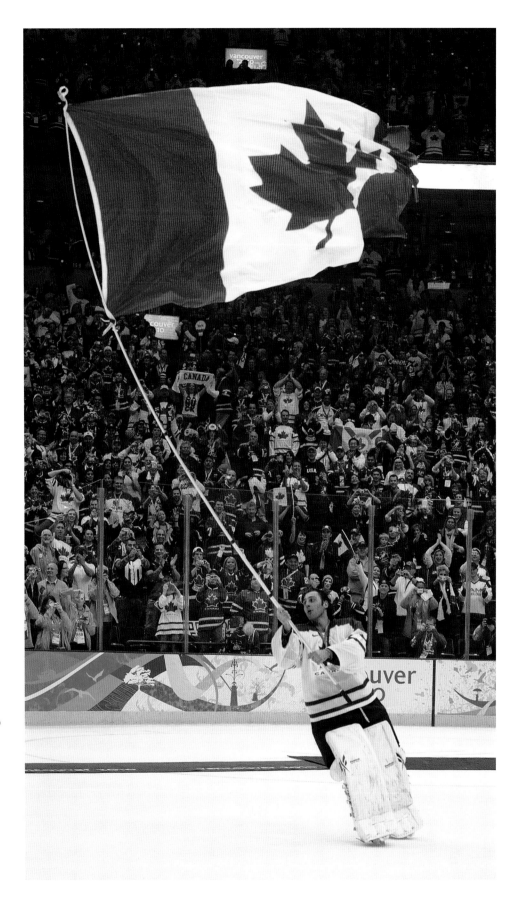

Facing top: Shirley Lewis at the start of the 2010 Olympic torch relay through the traditional lands of the Squamish, Lil'wat, Tsleil-Waututh, and Musqueam First Nations. **Mark van Manen/PNG**

Facing bottom: On the final day of the 2010 Olympics, thousands on Granville Street in Vancouver celebrate Canada's men's gold medal hockey victory against the U.S. **Stuart Davis/PNG**

Right: Roberto Luongo, pictured after Canada defeated the U.S. to win the gold medal in men's hockey at the 2010 Olympics in Vancouver, was goaltender for the Canucks, 2006–14. **Ric Ernst/PNG**

Facing top: Burnaby soccer star Christine Sinclair, pictured with her bronze medal from the 2012 Olympics, competed in four FIFA Women's World Cups, and won four professional titles. **Ward Perrin/PNG**

Facing bottom: Burnaby skip Kelley Law, pictured with Kristen Recksiedler (left) and Shannon Aleksic at the 2011 Scotties Tournament of Hearts, won bronze at the 2002 Olympics. **Gerry Kahrmann/PNG**

Above: Langley's Danielle Lawrie-Locke pitched in the 2018 Canada Cup International Softball Championship at Surrey's Softball City, which Canada won over the U.S. **Arlen Redekop/PNG**

Above: After Hong Kong gave Vancouver six dragon boats during Expo 86, the sport flourished, and the city now hosts North America's premier dragon boat racing festival. **Ward Perrin/PNG**

Facing top: The Terminal City Roller Derby league was founded in 2006 by Michelle "Micki Mercury" Lamoureux. Pictured are Riot Girls and Public Frenemy in 2013. **Arlen Redekop/PNG**

Facing bottom: Vernon tennis player Vasek Pospisil (right), who won the 2014 Wimbledon doubles title, with Milos Raonic (left) and Team Canada after his 2015 Davis Cup win over Japan. **Ric Ernst/PNG**

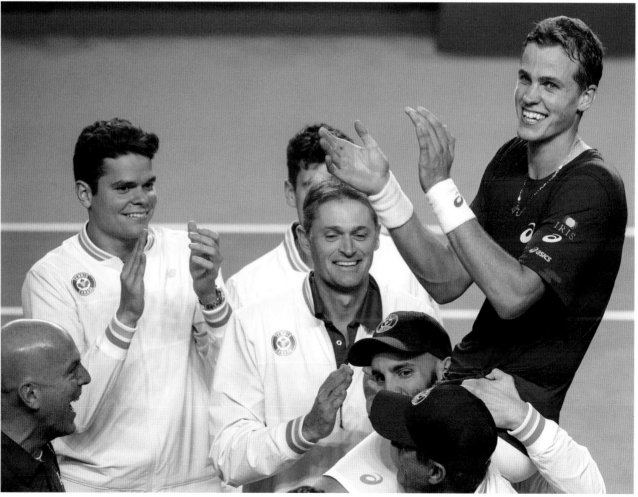

Above: The Vancouver Canadians, a minor league baseball team in the Northwest League, at their home field, Vancouver's Nat Bailey Stadium, in 2017. **Gerry Kahrmann/PNG**

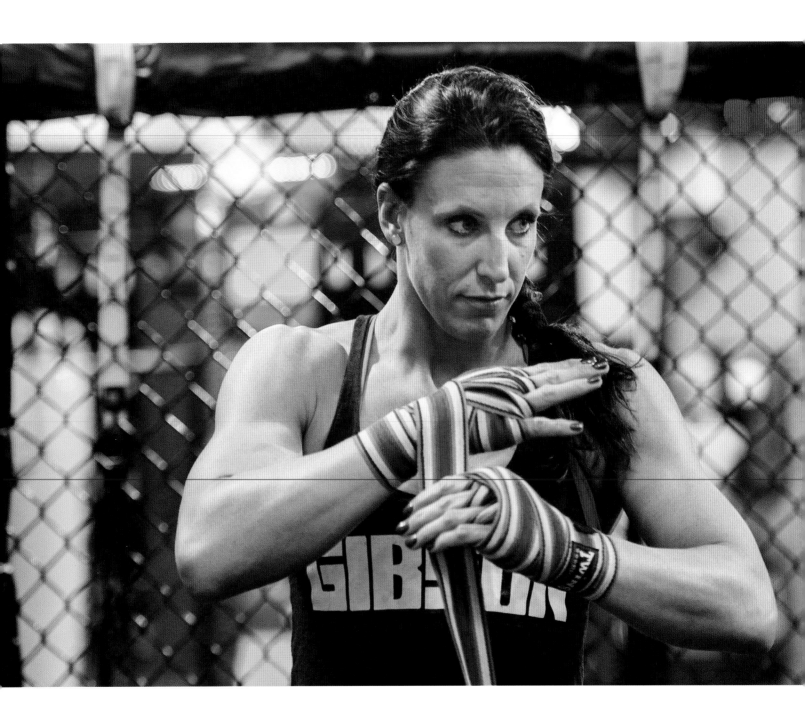

Above: Julia Budd, pictured at Gibson MMA in Port Moody, won the inaugural Bellator Women's Featherweight World Championship in 2017, and retained her title in 2018. **Gerry Kahrmann/PNG**

Facing top: Williams Lake's Gurdarshan (Gary) Singh Mangat, pictured with his championship belt in 2011, is the first Sikh to win a featherweight title in MMA history. **Steve Bosch/PNG**

Facing bottom: Richmond MMA fighter Arjan Singh Bhullar, the first Indo-Canadian to sign with the UFC, won gold in freestyle wrestling at the 2010 Commonwealth Games. **Ric Ernst/PNG**

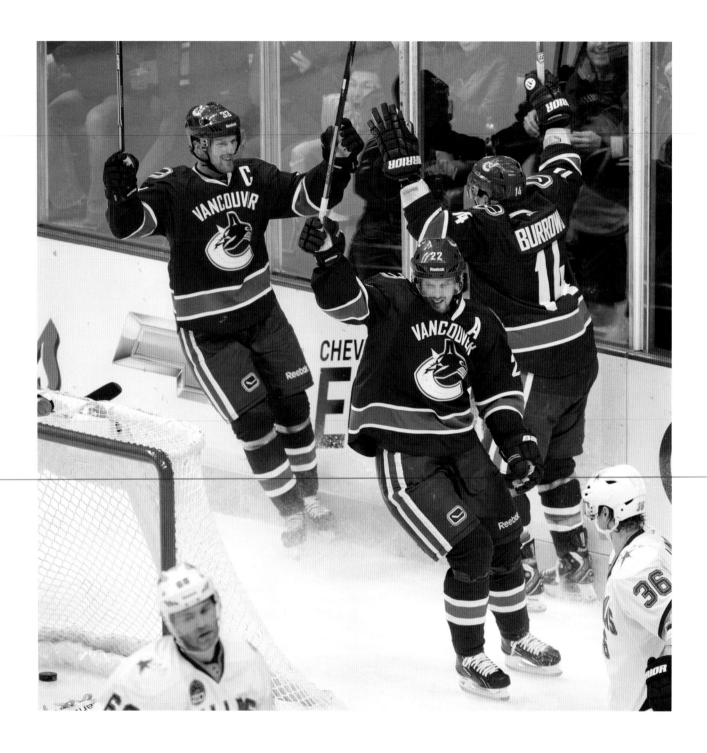

Above: In 2013, Henrik Sedin (left), Daniel Sedin, and Alex Burrows celebrated Henrik passing Markus Naslund as all-time Canucks scoring leader with 757 points. **Arlen Redekop/PNG**

Facing top: North Vancouver's Lauren Woolstencroft won five golds in alpine skiing at the 2010 Paralympics, a record for any Canadian Winter Paralympian or Olympian. **Mark van Manen/PNG**

Facing bottom: Mission's Brent Hayden, pictured winning the 100-metre freestyle at the 2012 Mel Zajac Jr. International Swim Meet at UBC, won bronze at the 2012 Olympics. **Mark van Manen/PNG**

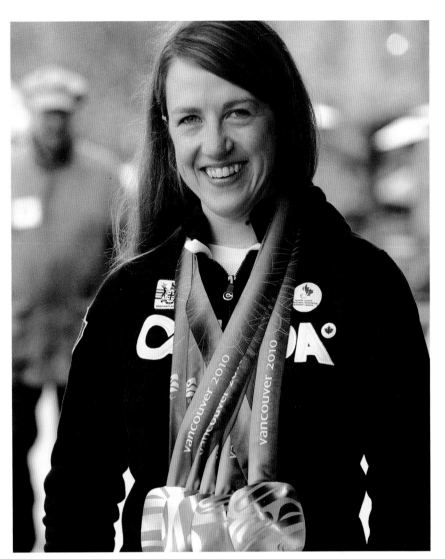

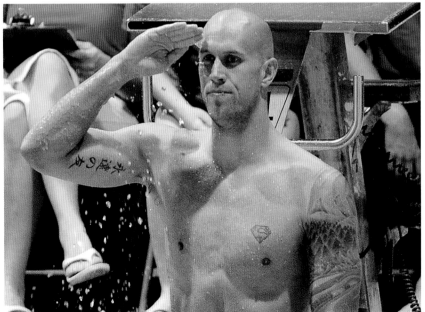

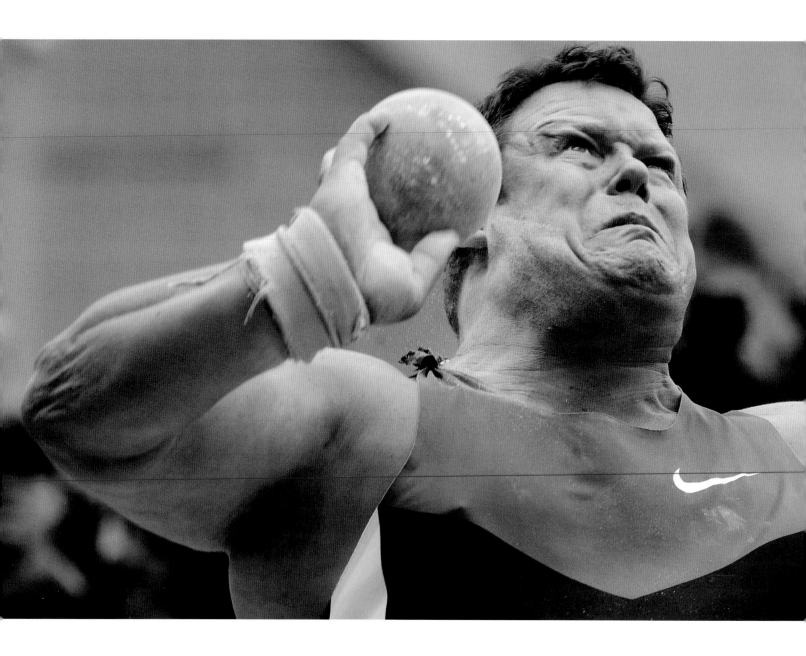

Above: Kamloops shot putter Dylan Armstrong, pictured at the 2012 Harry Jerome International Track Classic, medalled at two World Championships, and won bronze at the 2008 Olympics. **Ric Ernst/PNG**

Facing top: BC Lion Geroy Simon, pictured breaking the CFL all-time receiving yards record (16,352) in 2012, won three Grey Cups, including two with the Lions (2006, 2011). **Les Bazso/PNG**

Facing bottom: Jockey Mario Gutierrez, pictured winning the forty-fifth Vancouver Sun Handicap in 2010, won the Kentucky Derby (2012, 2016) and the Preakness Stakes (2012). **Mark van Manen/PNG**

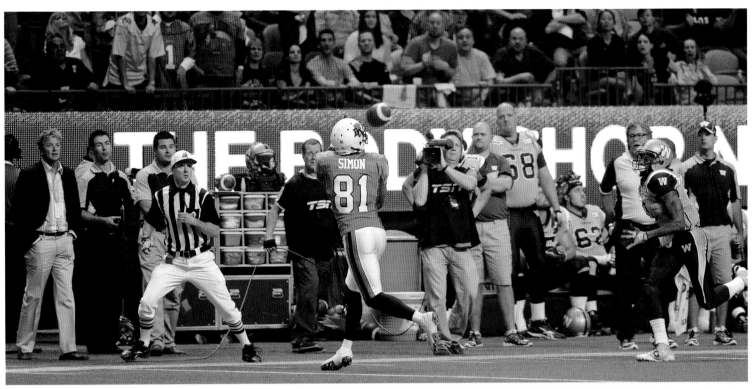

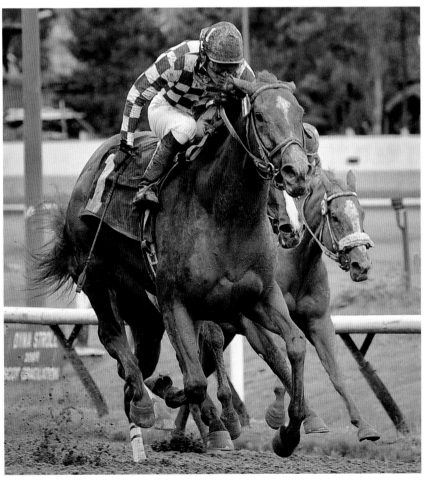

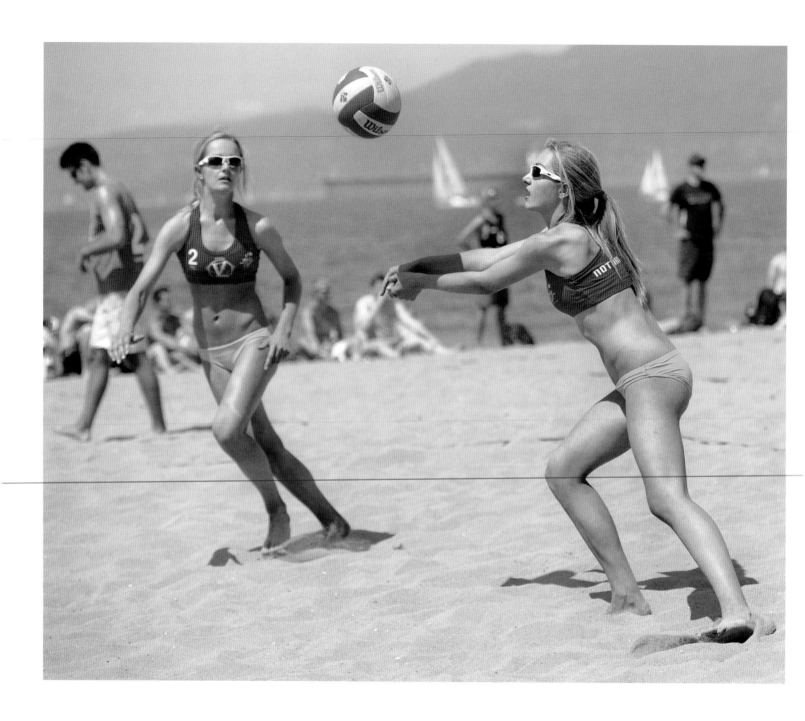

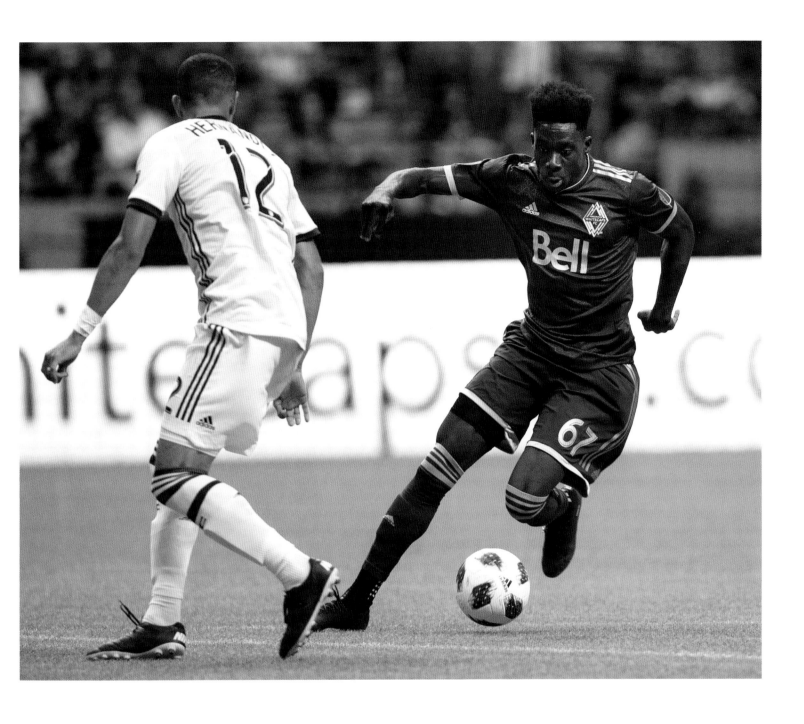

Facing: Tsawwassen twins Nicole (left) and Megan McNamara, pictured at Kitsilano Beach in 2012, won the 2018 NCAA national title, and were Canadian champions at the beach volleyball nationals. **Jason Payne/ PNG**

Above: Whitecaps' Alphonso Davies (right), who was born in a refugee camp in Ghana, won Canada Soccer's 2018 Canadian Player of the Year at age 17, and signed with Bayern Munich. **Gerry Kahrmann/ PNG**

Back page: Top and second row: **Gerry Kahrmann/PNG**; third row, from left: **Gerry Kahrmann/PNG**, **Gerry Kahrmann/ PNG**, **Arlen Redekop/PNG**; bottom row, from left: **Gerry Kahrmann/PNG**, **Gerry Kahrmann/PNG**, **Chris Relke/PNG**

173

INDEX TO THE PHOTOGRAPHS